P9-CLO-211

Michael Woods

DOVER PUBLICATIONS, INC., NEW YORK

Dedication
To Oliver, Sue, Ruby, Boswell, Poppy, Lily and
Holly

© Michael Woods 1989
First published in 1989 by B.T. Batsford, London,
under the title *Starting Landscape Drawing*

All rights reserved. No part of this publication may
be reproduced, in any form or by any means,
without permission from the Publisher.

Printed and bound in Great Britain

Library of Congress Cataloging-in-Publication Data

Woods, Michael.
 [Starting landscape drawing]
 Landscape drawing / Michael Woods,
 p. cm.
 Includes bibliographical references.
 ISBN 0-486-26387-8
 1. Landscape drawing—Technique. I. Title.
NC795.W6 1990
743'.836—dc20 90-2904
 CIP

Contents

Choosing a subject

Ahead, the road forked. Between the diverging ways and the horizon lay a triangle. The night had been clear and the early December morning revealed a totally frosted landscape. The sun was bright, low in the sky, and Stonehenge caught the orange light, the surrounding fields seeming fused and unified in their grey-green coating.

In that moment the subject caught me, and although I could not stop then, the memory of that landscape and man-made construction was so strong I knew I had to return to draw it (Fig 1). This, to me, is what landscape is all about.

When it comes to choice, I think those chance circumstances which put the artist in the right place at the right time are very precious (Fig 2). If it is possible to react at that moment, then the results can have a valuable spontaneity and freshness (Fig 3). However, the selection of the actual view can take time; it is all very well to look here and there, walking around in circles to see what the possibilities are; but if a return visit is not possible, valuable drawing time will be lost. So instant decisions are sometimes necessary, and making them will help to develop experience.

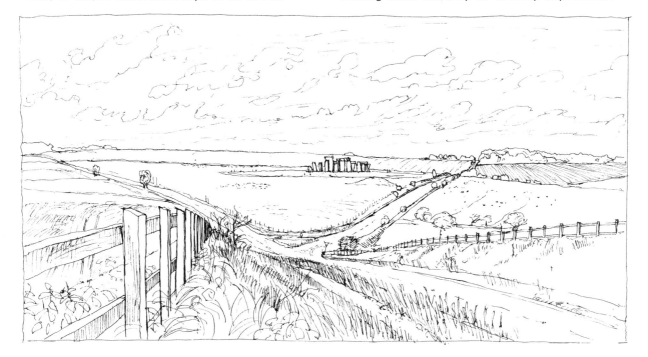

1 *Stonehenge lying within a triangle of two roads and the far horizon. Drawn with pen and Indian ink.*
The weather conditions were not good, but once dry the waterproof ink resisted spots of rain

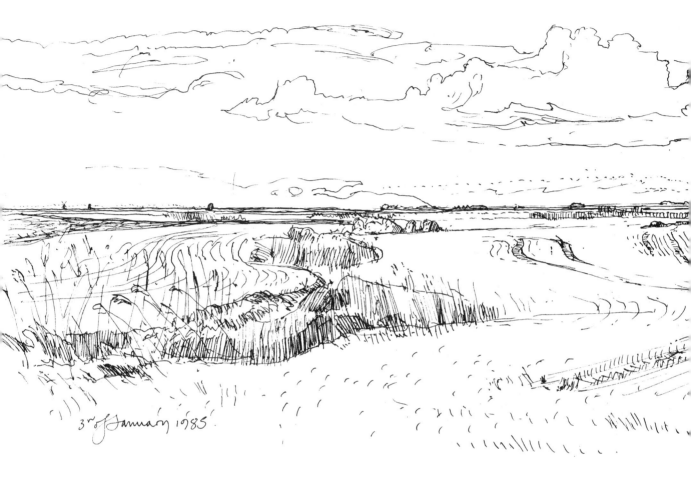

3rd of January 1985.

On other occasions, there will be time to ponder on some of the more subtle adjustments, which can make a lot of difference to the end quality of the picture. Rather than rushing into the drawing, consider what may relate to it. What time of day is it? How long will the conditions last? Are the clouds going to increase or disperse? Will it be possible to return to the same location at the same time of day? The answers to questions of this sort will help to determine the size to work, the time it will take, and the materials to use.

A drawing can show the proportions of a landscape, the size of trees, the direction of hedges and roads, where shadows fall and the shape of the clouds. It cannot create the heat of the sun, blow wind on your face or have the smell of cut grass or salt sands, so a successful drawing must contain a finely judged set of elements by which the mind and eye can be stimulated to recollect those sensations.

The choice should be for shapes, above all; shapes which can be recorded. Strong shapes created by light and shadow, emphatic textures such as ploughed fields, dramatic shapes found in cliffs, hills and clouds; close at hand, large leaf shapes and some contrast with man-made elements – all these offer the artist a framework on which to build the drawing. However attractive the view, its success as a drawing will depend on the shapes which you can extract from it (Figs 4 and 5).

Equally evocative that frosty December morning were the patches of fog, but though I could feel their chill wetness through the car window, there were few shapes to understand. I would not return to draw the fog!

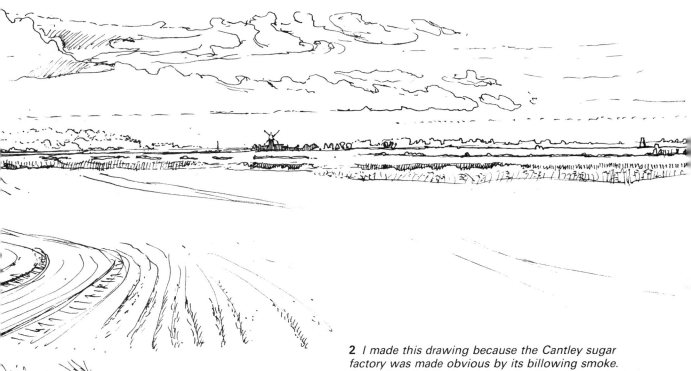

2 I made this drawing because the Cantley sugar factory was made obvious by its billowing smoke. But although it had a noticeable effect, its part in the whole landscape was tiny

3 A large bonfire close by a derelict mill, seen from a boat on Breydon Water, Norfolk. Drawing time could only have been about 30 seconds

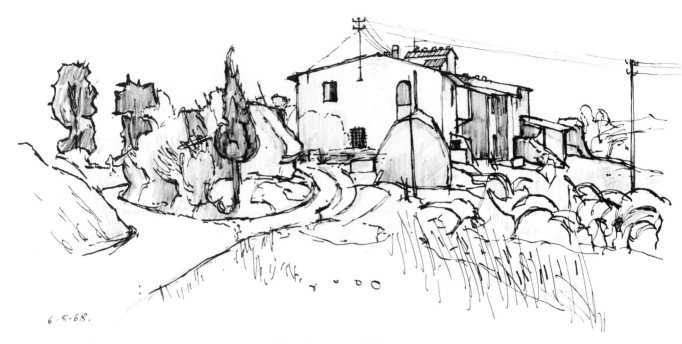

6.5.68.

4 *An Italian landscape drawn in pen and ink with some indication of tone added with soft pencil. The shapes were given priority*

5 *Though it would be possible to return to the same coastal site, the particular cloud formation would never be quite the same*

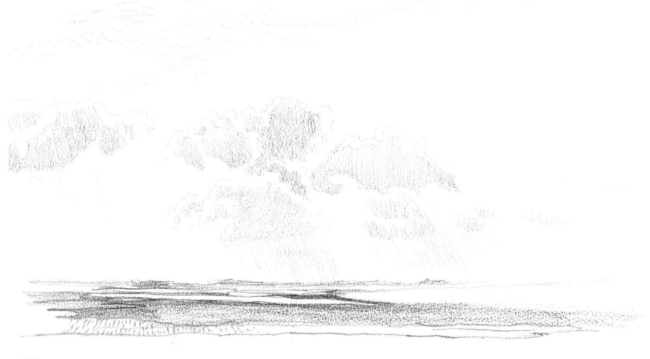

2

Atmosphere and mood

A landscape is very similar to a person, for the mood, or the situation, has an enormous effect on how we react to it. The shape of a hill or tree can look very flat in grey drizzle (Fig 6). There will be no shadows and little tonal change in darks and lights. On a bright summer day, the clouds passing behind the same hill will make it seem closer (Fig 7). The trees will have shadows beneath them, and if the sun is early or late, the hill will be moulded by the directional light (Fig 8). So it is not so much the actual place and its nature, but how it appears under various conditions. Mysteries and thriller stories frequently seem to depend on low light, deep shadows, and rain beating at the windows of remote country houses for their atmosphere – bright sunlight and small cumulus clouds change the mood, but not the actual place.

The time of year is, of course, important, and the position of the sun on the form of the land can change quickly. If shadows are clear, then predict how long they will remain. In the early morning the sun will rise quickly and any cast shadows will shorten. At the end of the day the reverse will happen; the whole quantity of light will drop and shapes will fuse together.

The view of a group of trees in full summer can look quite different in midwinter, when they are leafless and the landscape beyond is revealed (Figs 9 and 10). The rich colours of autumn leaves, which can be everything in a painting, become meaningless in a drawing, but the overall shape and the contrast of one tree with another become much more important (Fig 11).

Lines can swing across a field (Fig 12), but later in the year, when the corn is standing, there is a solid pile across the surface (Fig 13). When harvesting starts, the thickness of the crop can provide crisp edges in the foreground (Fig 14).

One of the values of atmosphere is that it can cause quite different parts of a landscape to fuse together. Far hills and rocks may interweave with misty clouds and should be drawn as such (Fig 15). At a distance, houses and trees may seem to be built together. Draw them as if they were (Fig 16). In a similar way, grasses and fences can seem to merge when in a dark foreground or seen against the light (Fig 17). This knitting of parts thought of as separate items is very important, for otherwise the drawing will appear as just a collection of objects, probably out of scale with one another and unrelated in any way.

The air itself can also help the feeling for space. Look at the view and divide it into four areas: the near foreground and the far distance, and two ranges in between. Any sort of haze or mist can help, as can areas of shadow. Whatever the subject, all the parts should lie in their distance place – 1, 2, 3 or 4 – and the further away, the paler or more gently they can be drawn (Fig 18). So whether the object is sharp like a metal bridge, or soft like a corn field, its rôle in the drawing will be modified by its place in space.

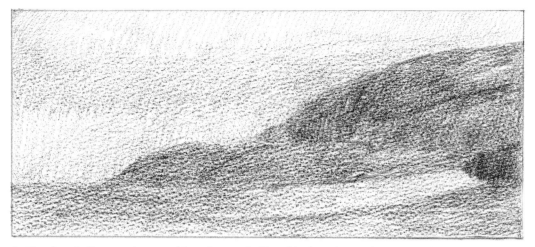

6 *The South Downs drawn with soft pencil. The drizzle reduces the range of tones*

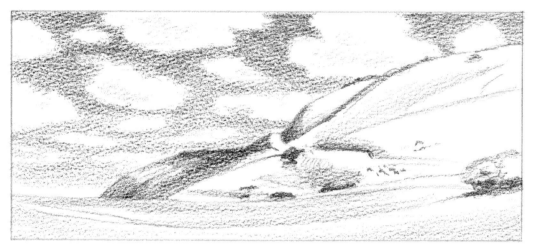

7 *The same view as in Fig 6, but with clouds passing beyond the hills*

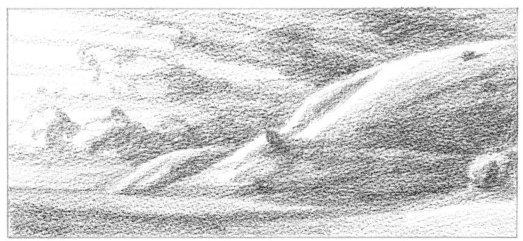

8 *The same view as in Figs 6 and 7, but seen with the sun low in the sky. All three drawings were made with a 3B pencil*

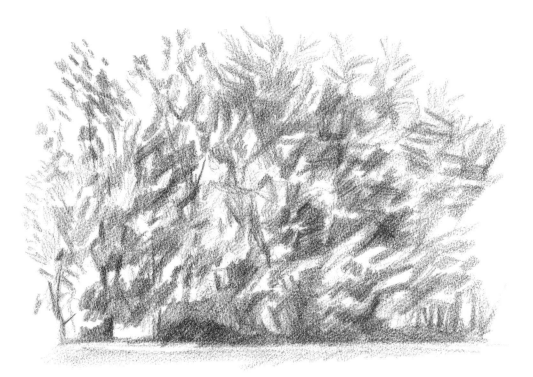

9 *A pencil drawing of a group of trees in high summer. The main areas of leaves were recorded by patches of shading*

10 *The same view as seen in Fig 9, but under winter conditions. A house which had previously been totally concealed is now clearly a main part of this drawing*

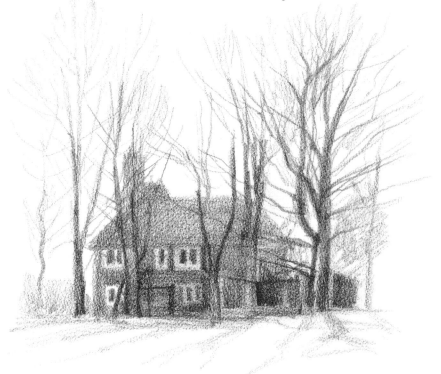

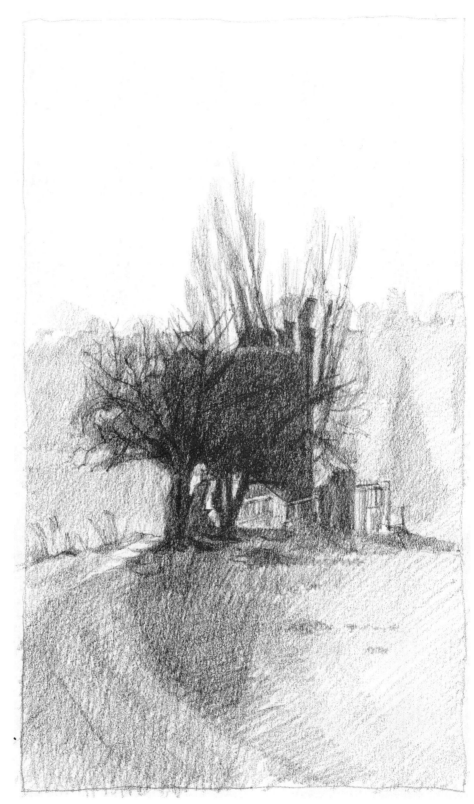

11 *A group of trees of different shapes seen against the light*

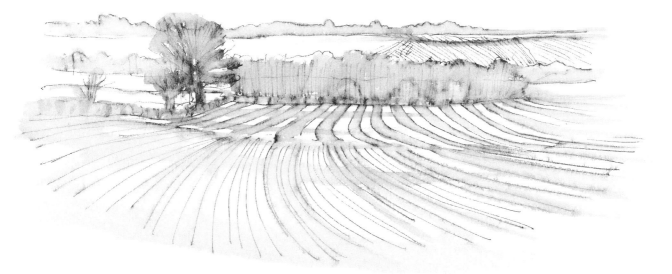

12 Lines of cultivation make clear patterns across a field. Pen and ink with a following water wash to make tonal areas

13 Corn fields drawn with white pencil on a half-tone paper. The light lines suitably describe the light areas

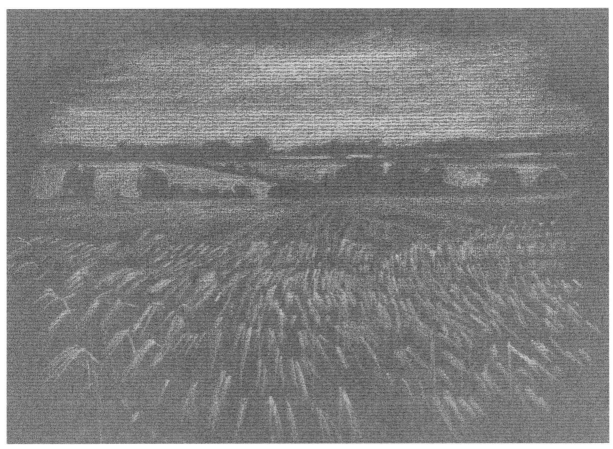

15

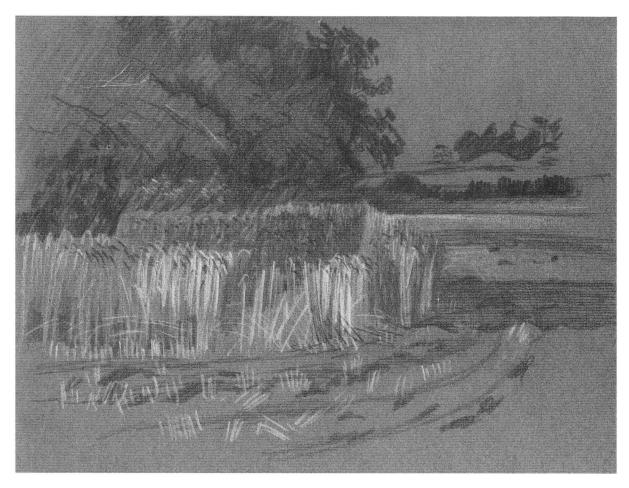

14 *White pencil and soft pencil describing the remnants of a harvested field*

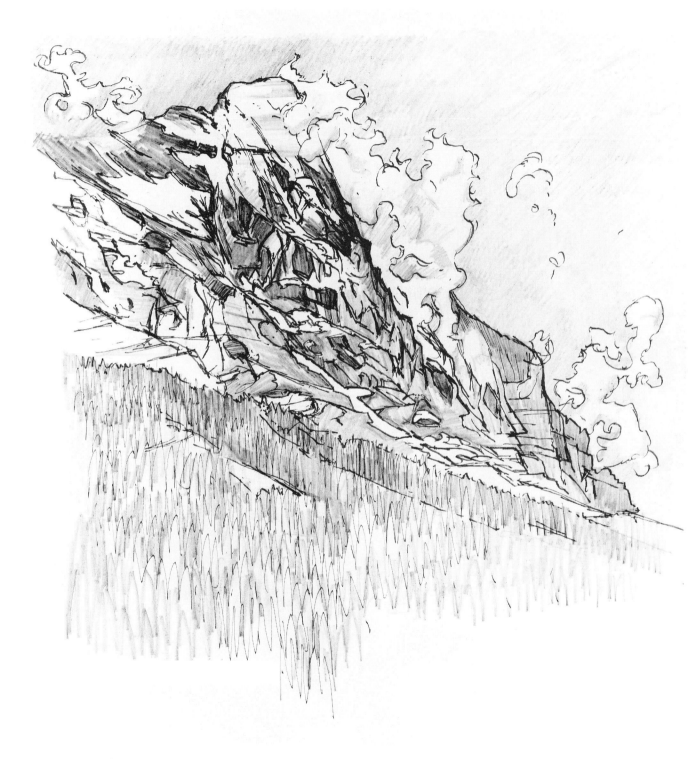

15 *The Eiger and the clouds forming on the north face were drawn as one. Pen, and tone added with a 3B pencil*

16 *The houses and trees were not thought of as separate or different objects. Soft pencil was used to create the dark tones which fused the shapes together*

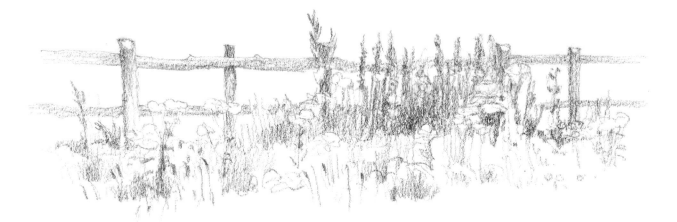

17 *Wild flowers at the edge of a field merge with the fence*

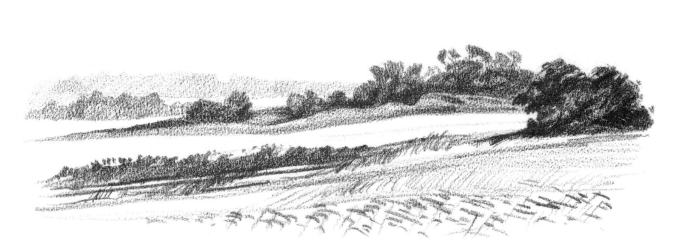

18 *A landscape drawn in four distance areas. The furthest is drawn the most gently, while the nearest has the strongest contrasts*

3

The view

Many little parts of a picture may add together to create a whole, but more often a strong central subject provides the focus around which other elements may fit. Imagine a barn, for example. The easiest view is often thought to be straight on, midway along the main wall, with the same amount to left and right, balanced and symmetrical. But this view gives little chance for describing the volume of the building – much of its character will come from its bulk. A better view to choose would be where two walls are seen; in this instance the thickness of posts and the angles of roof lines and doors will be given a clarity which will make for more positive drawing (Figs 19 and 20). If the central subject is a group of trees, take a view in which they overlap one another and, by the lightness or darkness of their leaves, or by the sides in shadow, have some alternative tonal contrasts (Fig 21).

How the eye moves into the picture is related to how the artist sees the object. When standing in a field, your eyes will be about 5 feet (1.5 m) above the ground, and your horizon straight ahead of you. Anything above your eye will have elements which descend to the horizon; anything below 5 feet (1.5 m) will rise to it (Figs 22 and 23).

It may be possible to change your viewing point, not only left or right, but up or down. Sitting on the ground can change your view quite dramatically: at the side of a standing crop the distant view can disappear completely, but wild flowers suddenly seem large and become the central object (Fig 24). On the other hand, climbing a bank or hill may reveal views, when looking down, which have a greater emphasis on the plan of the shapes (Fig 25).

Coincidences are curious. You may not notice until you are half-way through a drawing that a pole in a field beyond a farmhouse looks as if it is appearing from the chimney pot, or that two clumps of trees, which of course you know to be separated by several hundred yards of field, uncomfortably line up edge to edge. Now it might seem that this sort of fact could easily be adjusted, and so it can – but at what cost? Nature and its man-made additions do have a very special tension in their placings and intervals, and personally I feel that the quality of landscape comes from this strange mixture of chance and purpose; the intervals and spaces, the shapes and sizes, become a sort of writing of a secret language (Fig 26). To not bother whether one field is really a bit bigger than another seems destined to end in the assumption that once you have seen one field, you have seen them all! I once counted the number of times I had drawn and painted a particular view – a simple farming landscape seen from a house – and it was over two hundred. That is not particularly remarkable, but I make the point because not once were those fields quite the same, and what I chose to represent from them was never quite the same. This applies to any landscape (Figs 27–30).

Now experience can be a nuisance! At the start you don't have it, but that is when you need it; later on, when you do have it, rules often need to be discarded because hunch and feeling take over.

So, some thought first. Once you have a clear reason for the selection, then the first marks can be made. But where? It is very easy, when you have finished, to know just how you should have

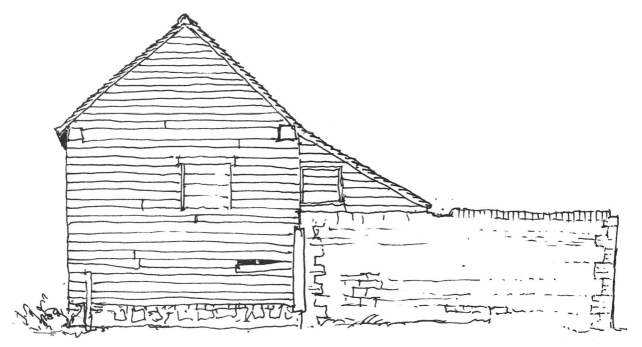

19 *A barn looking straight on to one main wall*

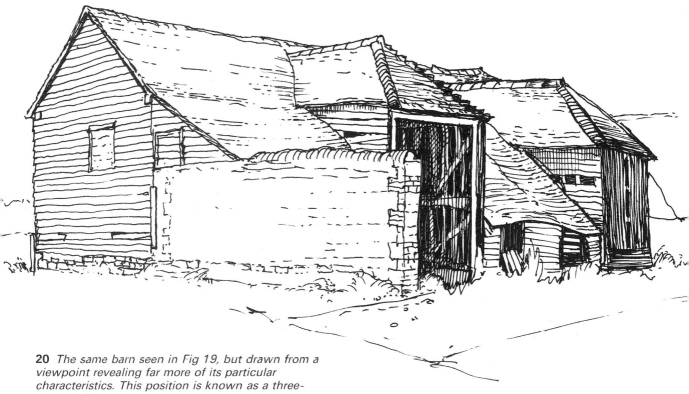

20 *The same barn seen in Fig 19, but drawn from a viewpoint revealing far more of its particular characteristics. This position is known as a three-quarter view*

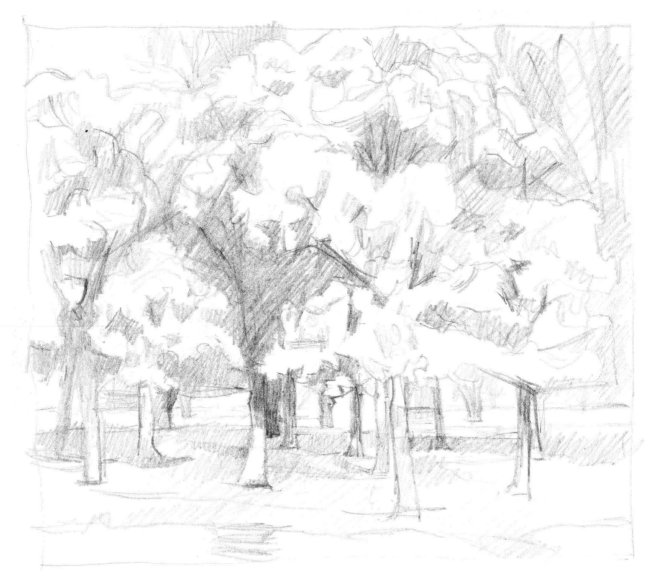

21 *A group of trees in Richmond Park, Surrey, animated by clusters of leaves in light and shadow*

started. For anyone drawing a still life group, or a model, the area of the subject is not too complex – all or part – and that choice can be given simple variations over a few drawings. But where does a landscape start – worse still, where does it stop? A clear central subject does give some guidance, but how much material should surround it? The only rule is that the whole drawing must make sense. Too little of something, and it may not be interpreted at all clearly; too much, and the focus is lost. In the very broadest terms, I would suggest a recipe of either two-thirds for a central object,

with one-third peripheral matter (Fig 31), or one-third central object, and two-thirds surrounding (Fig 32). At least it gives some place to start!

The materials used can be a pen or 2B pencil and a sketch book, say A3, $11\frac{3}{4}$ in \times $16\frac{1}{2}$ in (297 mm \times 420 mm). I would suggest that when starting to work from landscape, line alone is used. Speed is often important and this will take less time; alterations are simpler – if using pencil, there is less to rub out. The line is going to work hard, for it will take on many jobs: shapes, where it describes the edges of forms (Fig 33); tone, where

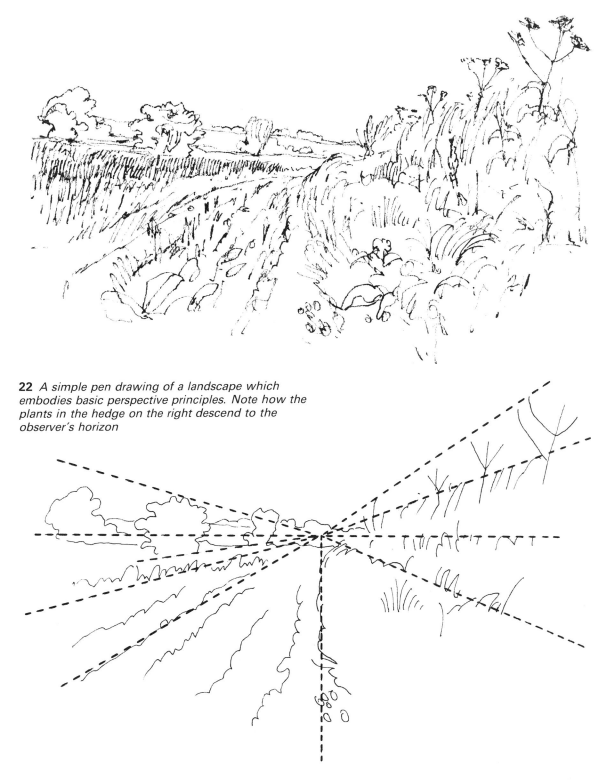

22 *A simple pen drawing of a landscape which embodies basic perspective principles. Note how the plants in the hedge on the right descend to the observer's horizon*

23 *The main lines of Fig 22 meeting on the horizon*

24 *Wild flowers loom large when the viewing point is low*

25 *A high vantage point can present patterns and lines with greater clarity than a low viewpoint*

lines are laid close together (Fig 34); texture, when the surfaces and materials are busy (Fig 35) and movement, whereby wind and cloud, grass and leaf may be brought into activity (Fig 36). But if line alone is to describe the range of qualities, some rationing must occur. For one area to show up, another area against it will be more effective if it remains untouched. A fault with some drawings is that every area can be developed to the same degree with the result that contrasts can be lost.

Let us assume that the central subject is the reason why you have chosen your particular view. Without making any marks on the paper, imagine you are drawing. How big would you make it? Now consider the surroundings. How much is needed to produce the environment? How much of the sky will set it all off, and what of the foreground? Visualising what might be drawn, and where, is most important, for through it the placing on the paper evolves and the choices become the marks of your pencil or pen (Fig 37).

Draw the central subject and think of the overall shape rather like a map (Fig 38). If there are any dominant characteristics, make certain that they are not suppressed in your version. Consider which sub-divisions make up the whole, and whether the whole can be divided into smaller parts (Fig 39). If you draw the whole shape, will it leave spaces capable of being divided into roof, door and windows? The other way around, if you draw roof, door and windows, one by one, will they add up to the correct characteristics of the whole shape? Then develop lines which will run through from one side of the drawing to the other – far horizon field boundaries, or paths and streams from the centre foreground and out of the picture (Fig 40). Though these lines may be interrupted by the central subject, they will 'feel' right if they can be sensed to tie up one side with the other.

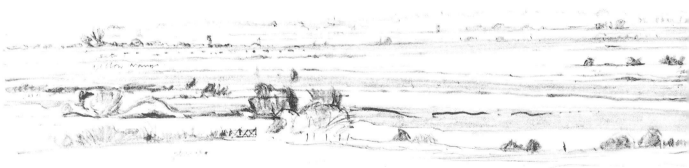

The far distance is not likely to present problems, for it will be visually simplified, but the foreground (stones and grass, leaves and flowers) can become over-emphasised and may drown your central object – the reason you were drawing there in the first place. So choose. Select those main characteristics which will describe what is in your view but also lead the eye into the centre focus of the drawing. The eye is marvellously sensitive and the hand will need much restraint to stop it going on and on because you can see something else. If the main object is a cottage in some fields, the end drawing should say to the observer, 'Here, look at this old cottage – by the way it is surrounded by some pleasant farmland'. It is not the same if the observer sees a drawing of some pleasant farmland, 'and, by the way, there's a cottage in it as well'. Right from the very beginning, draw what you mean to draw.

But if the quality of the landscape is just that – a complex set of interwoven hills and fields without any clear centre – where then do you start? This is more difficult, for the choice and selection then becomes more dependent on your sensitivity to the overall characteristics of that particular landscape. What are the shapes of the parts; what sort of shapes are the fields? Sometimes it is not until we have seen a completely different landscape from the one we are accustomed to, that we notice what its real qualities are. They may be very subtle, and are often surprisingly simple: many hills are rounded – we talk of 'rolling hills' – but what sort of shape are they exactly (Fig 41)?

So, in many ways, the observing artist has to take on the rôles of geographer, meteorologist and even farmer. The particular types of crops and trees grown will play a crucial rôle in how the land is worked, and therefore in what the artist draws.

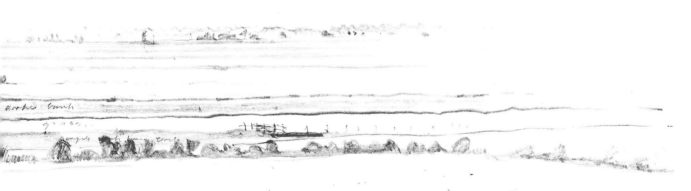

26 *The intervals and subtle proportions of a stretch of marshes by the River Yare in Norfolk. A pencil study in preparation for an oil painting. I added further written information concerning colours and features*

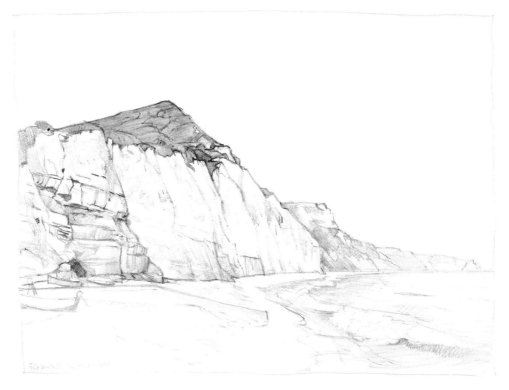

27 *The beach at Sidmouth looking east. Compare with Fig 28*

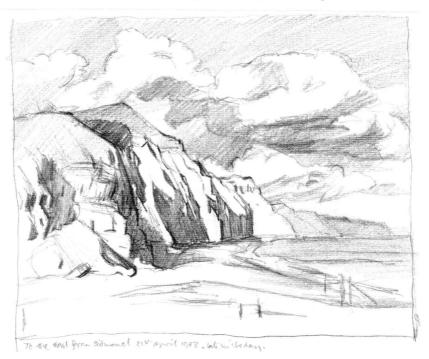

28 *The same subject as in Fig 27, but drawn two years later. The clouds and light were quite different and created greater tonal emphasis*

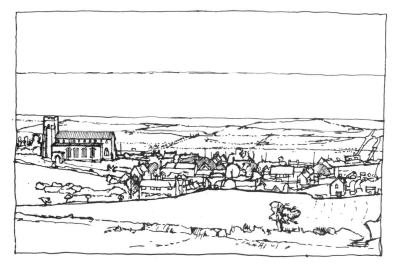

29 *Salthouse, on the north coast of Norfolk, drawn with pen, in 1958*

30 *A similar drawing to Fig 29, but with different viewpoint and composition. It was drawn with water soluble ink and the tonal wash created by wetting the lines with a brush*

31 *This drawing of Portland Bill was made in black and white wax chalk. The main subject in this version occupies two-thirds of the whole area, leaving one-third surrounding it. Compare with Fig 32*

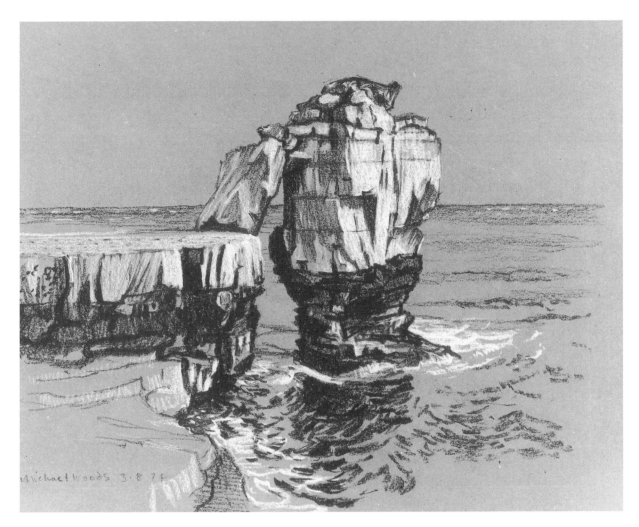

32 *The same subject as in Fig 31, but with the central subject given about one-third of the area, while the sea and sky occupy the other two-thirds*

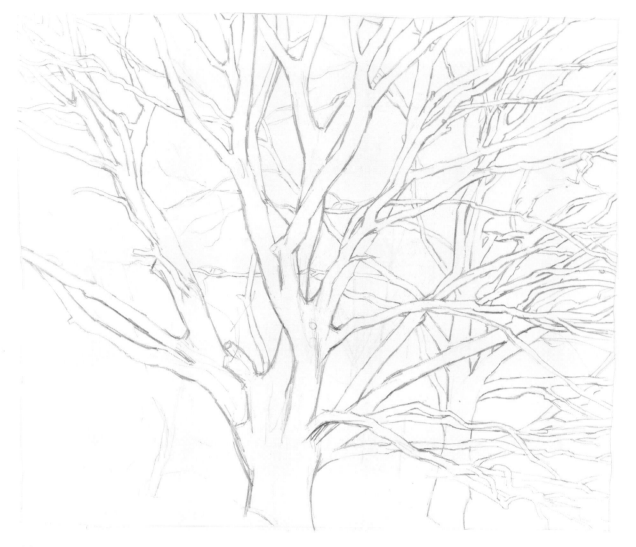

33 *The forms of trees described by pencil line*

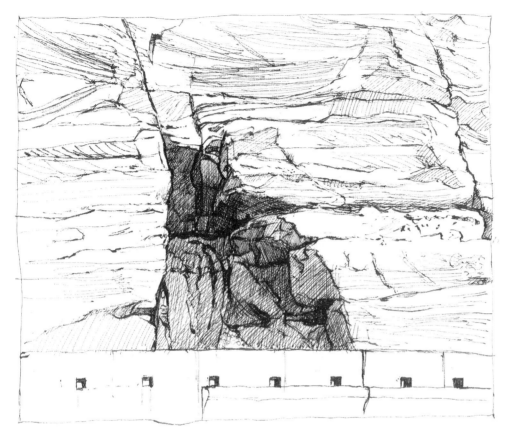

34 *Pen and ink used to draw cliffs at Sidmouth, Devon. The darkest tones are created by laying the lines closely together and overlaying subsequent lines at an angle to the first groups. The process is called cross-hatching*

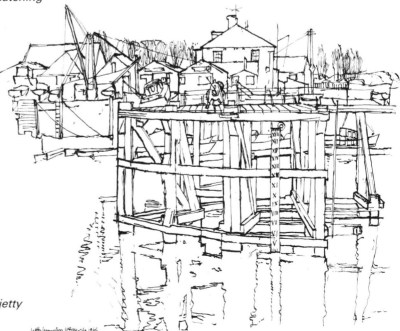

35 *Lines of ink describing a complex wood jetty and boatyard buildings at Littlehampton*

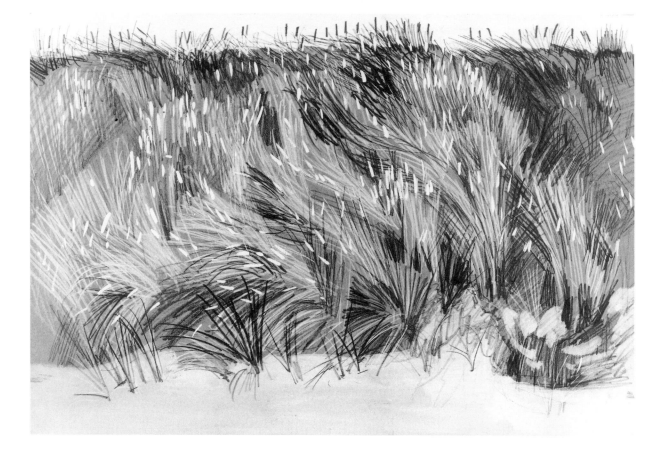

36 *Marram grass blowing in the North Sea breeze at Holkham, Norfolk. White pencil and ordinary pencil, with some touches of white poster paint on dark grey paper*

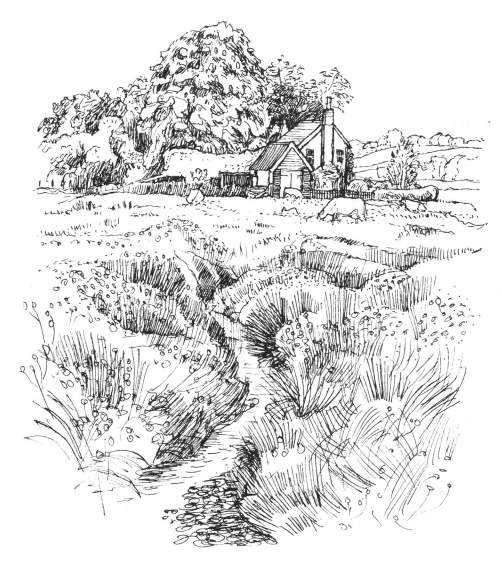

37 *A pen and ink drawing of a cottage, trees and water meadow in the Tas Valley, south of Norwich*

38 *A diagramatic version of Fig 37 showing the areas initially considered. The actual marks in the real drawing would have been very slight at this stage*

39 *The first areas depicted in Fig 38 are sub-divided again, with only dots or short lines to make trial decisions*

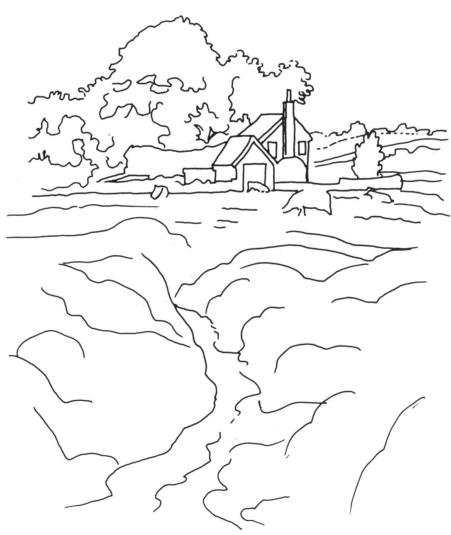

40 *The whole area of the composition is developed with the elements which run through from one side to the other and out at the bottom of the picture*

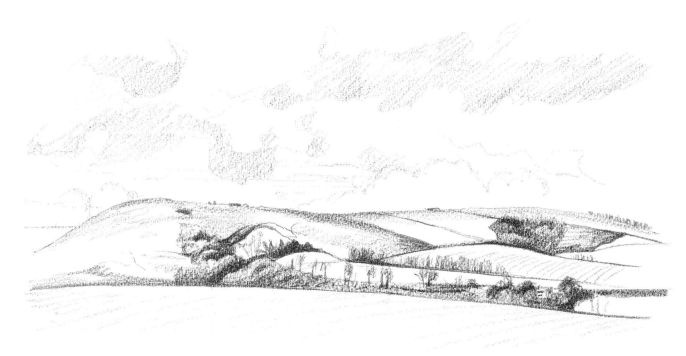

41 *Hill shapes have to be carefully considered*

4

Trees

Think of trees mainly as big masses – showing dark against lighter sky, and even dark against fields (Fig 42). Most drawing materials can be made to produce a rich darkness, but trees may require a subtle variation in the dark to enable the shadows, the hollows between branches, and even something of the varied texture of leaves, to be described. This means that a sequence of additional application is likely to be needed.

If the drawing material is pencil, use of a long tip will enable shading to be applied broadly as a general, overall tone into which richer darks can be developed. However, the shading should never be so heavy as totally to dominate or obliterate the surface texture of the paper (Fig 43). Watercolour wash (or diluted ink wash) can be used in a similar way, and can give a richness or darkness of tone which is much stronger than that achieved by pencil (Fig 44). With pen and ink, the cross-hatching used to create tone must be kept very fine, otherwise when trying to develop darker values the cross-hatching lines themselves may dominate (Fig 45). On the other hand, if they are laid too close, there will be little chance for further darkening without making a solid black.

Every type of tree has a characteristic shape – both of the whole form and of individual branches and groups of leaves (Figs 46 and 47). The artist must seek out these special shapes, as otherwise all trees can become anonymous lollipops on sticks. Like many things in a landscape, trees are not flat cut-outs; they exist in three dimensions, going back and forward as far as they reach from side to side. In order to describe this mass, subtle changes in tone must be noticed and the shading varied accordingly (Fig 48). A dark side will

contrast with a lighter area, and shadows beneath the dark masses will help to reveal some of the volume of the tree. Where trees stand close together their branches will intermingle, and even from only 50 yards (50 metres) away, it is often difficult to distinguish where one starts and the other stops (Fig 49).

Further away, a whole wood can appear as one and must be drawn as such (Fig 50). The knowledge of individual leaves on twigs on branches must be abandoned for the sake of the whole cluster. If there are many different types of tree, then the whole group will have an overall shape made up from the close association of the individual shapes. Where the branches grow thin, or in winter when most of the main areas are made up of bare twigs and branches, the resultant tone will be paler. The drawing will have to be a summing up of dark branches, a fine mesh of twigs and the sky beyond. Although the twigs are there, to draw them when seen at a distance will produce a very over-complicated image. Obviously, this generalisation is more likely to look successful when the trees are in the middle or far distance, and not the main central subject. Without hesitation I would say that, unless a tree is very close, you should simplify it every time. The far distance will give a guide, for there the massing will be total and no difficulty will be found in accepting the simplification.

Nature does produce relief to large areas of leaf in the form of dead branches and even whole dead trees. Artists have always used the pale silvery boughs to make useful contrasts in tone. If you do find a view which includes such elements, take care that you do not draw a line around the trunk

or branch and later shade around it. An over-thin area will result, even on small branches, for as shading is introduced the line will become part of the background, and the resulting light area will suddenly appear much thinner than first intended. A more reliable procedure is to shade only, creating the line by approaching the branch with care and concentrating on the shapes between the parts, so that what is left becomes the light branch.

Passing clouds and clear sun, which combine to add animation to all landscape, can do much to separate and isolate various areas of trees. The conditions are likely to pass quickly, but they will also repeat so, with some light lines and dots for laying out the composition areas, watch for the way in which the shadows pull a particular group of trees together (Fig 51). Take a plunge and draw the group by shading as you can remember it – notice which areas should be kept light to contrast with other dark areas as the shadow of the cloud passes by. Ration how much you allow to be dark and how much light. This will be more successful than making a line drawing first and then trying to fill in some of the areas with shading. The effect is of emphatically light areas set against dark areas.

Lines describing trees become effective with closer viewing: you see a few branches with individual leaves, where bark and berries or fruit take on a rôle of pattern and texture, rather than just areas of tone (Fig 52). You must still allow some contrast, as otherwise the whole picture can become grey – not in colour, but simply because lots of lines can accumulatively produce a texture which will read as a tone of grey. Some areas left as plain white paper will provide refreshing contrasts – and a few areas of solid shading might give dark areas of richness (Fig 53). A line which is continuous, or near continuous, can freely interpret the shapes being observed. Much drawing is involved with translation rather than reconstruction; a purely botanical statement may not always grasp the vitality of the shapes in the wind, the sun and rain. The success of a drawing can depend as much on shrewd summing up as on factual representation.

Remember that leaves move, turning and twisting as the wind gusts; even whole branches move, particularly if the tree is a pendular sort, like a weeping willow. This movement may be echoed in the direction of clouds and the bending of grasses, and is a vital part of any landscape. It will be by contrast in the direction of lines that some of this feeling for movement can be shown. Posts, poles and thick trunks of trees do not bend, and can stand in clear contrast to the things which do (Fig 54).

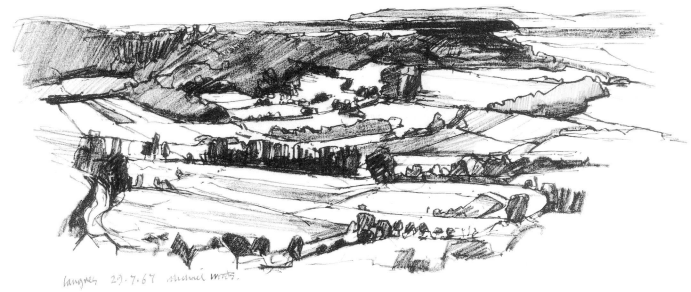

42 *A French landscape at Langres dominated by rich dark clusters of trees*

43 *A group of trees drawn with pencil producing soft to dark greys*

44 *Compared to Fig 43, pen and wash can produce richer, darker areas*

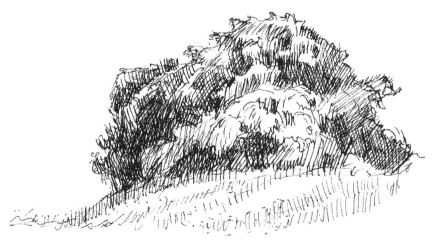

45 *Pen drawing enables a gradual development to take place but the lines and spacing need careful application*

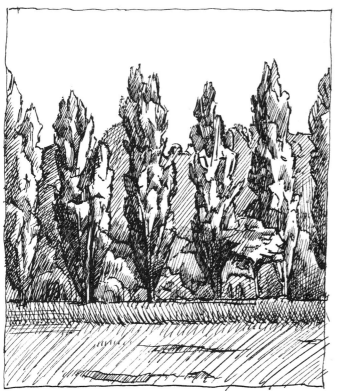

46 *All trees have characteristic shapes*

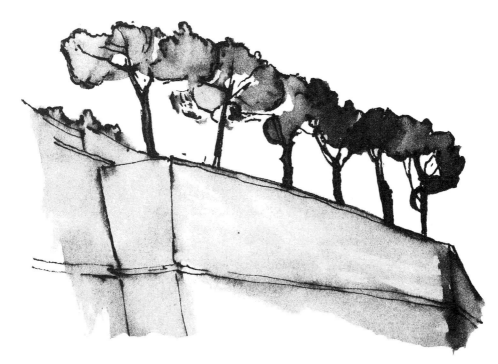

47 *Trees on the wall of the Vatican in Rome*

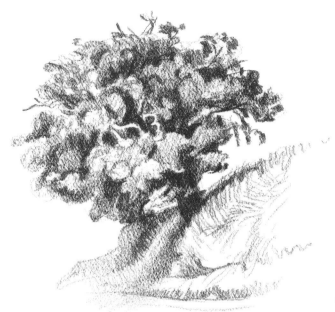

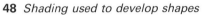

48 *Shading used to develop shapes*

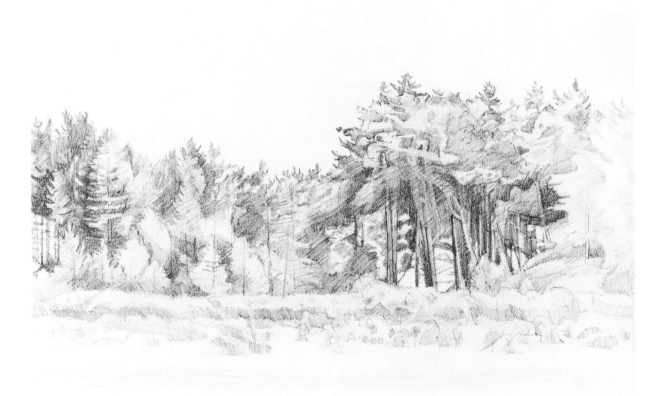

49 *Holkham Meals, Norfolk – the trees fuse together forming an effective wind break but a complex set of shapes for the artist. This drawing was made with a 4B pencil on a pale toned paper. White poster colour was applied to lighten the sky – which also has the effect of apparently darkening the trees and ground*

50 *A wood drawn as one overall shape. Only the
top edges of individual trees are drawn with a paler
tone where the sun catches the top of the form*

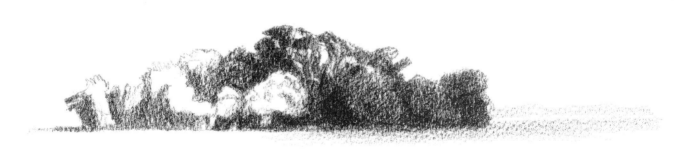

51 *On a bright day with clouds, passing shadows
can pull trees together. Draw the whole shape gently
and then wait and watch, adding and darkening
shading as the light changes. Knowing when to stop
may be difficult*

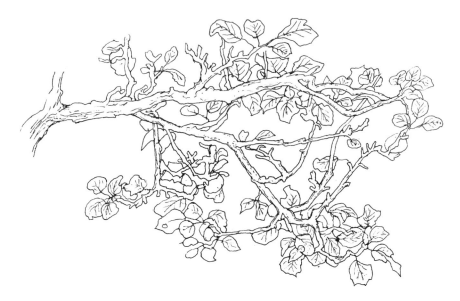

52 *Lines describing a branch close up*

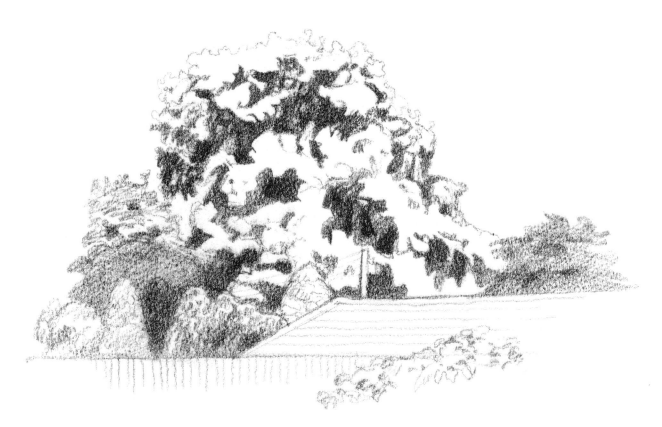

53 *This drawing preserves areas of untouched paper in the large tree, making strong contrast with the dark shadows. Leaves can frequently tempt the artist into working the whole area, resulting in an overall grey*

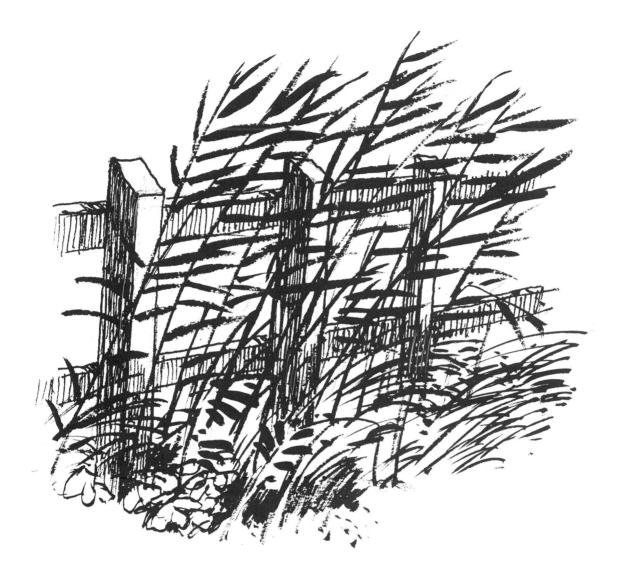

54 *Notice how the movement of grasses and reeds can be contrasted against vertical posts*

5

Architecture and sky

In any landscape, buildings produce one of the strongest punctuations because of their crisp shape and tonal contrasts (Fig 55), yet when partly hidden behind hills and trees, they fuse surprisingly well (Figs 56 and 57).

They will not, however, sit comfortably if their construction is suspect. Not only is it important to keep the overall appearance right, but the many smaller subdivisions also need just as much care. All the parts of a regularly constructed building follow the same simple guidelines. It is the rôle of perspective to keep this sound appearance, and there are some very straightforward rules. However hilly the environment, your horizon will be an imaginary straight line directly ahead of you. The most obvious example is seen if you stand on a beach: your horizon is where the sky meets sea. If you go to the top of a 200 foot cliff, your horizon is still straight ahead of you. Most of the time we do not see much of an actual horizon because closer things get in the way, but in order to sort out perspective, it must be imagined. Your horizon should not be confused with the skyline.

As most buildings are pretty regular, for explanatory purposes I will assume they all are. Thus the ground line and gutter line, the bottom edge of a roof and the ridge of the roof will have been constructed parallel to each other. However, although we understand this, they will be drawn not parallel, but converging as they travel away from your view, until they meet at a point (called a vanishing point) on your horizon. If the building seen is totally below your horizon, then the ground line, gutter line and roof apex will all rise to it (Fig 58). If you and the building are standing on flat ground, the ground line of the building will

rise, but both the gutter line and ridge of the roof will fall to your horizon (Fig 59). If you are looking up at a hill, with a building above, then all the lines will descend to the horizon (Fig 60).

Extreme cases, strangely, do not present a very great problem, for the angles of the parts are pretty obvious. When, however, a building is in mid-distance and just about on your horizon, the very slight rise or fall of a line can be a sensitive judgement to make. Simply ask yourself the question, which end of a wall is furthest away? If a line is above your eye, then it will descend as it travels away; if below your eye, it will rise. In many landscape situations, the ground line of farm buildings and houses will not be seen; it will be mainly the roof directions which appear. If buildings are at different angles from one another, then they will have different vanishing points, but these will all be somewhere on the same horizon – your horizon. Of course, perspective construction applies not only to buildings but to the whole landscape.

The nature of buildings varies considerably from place to place, but all have one thing in common: they have a volume and are made of fairly thick materials. The thickness, and parts which are jutting out or recessed, also creates shadows without which the image can look like a paper cut-out (Fig 61). It still surprises me how the addition of the rectangle of a window or door will suddenly activate an otherwise blank drawing (Figs 62 and 63).

On the other hand, the materials of which a building is made can catch out the draughtsman. Unless the range is close, most textures will evaporate. Only the strongest characteristics

should be stated, and even those should be kept in place. There is always a danger that the sensitive eye will be over-eager to draw all and every texture and pattern. The belief that the success of the drawing will depend on their faithful recreation needs to be reconsidered. If you close your eyes until they are almost shut, the amount of light and the degree of detail will be considerably limited. In this state, what is perceived will be the most economic version (Fig 64) of what might be seen (Fig 65). It is this degree of observation which should be drawn, enabling the value of each tone or agitated texture to be 'kept in place'. It means that the drawing, rather than the objects which are the subject of the drawing, will take on the dominant rôle. Interestingly, if the translation is right, there is every likelihood that the original textures and qualities will be recognisable.

I am not sure at which point a landscape becomes a townscape, but if there is a larger or more dominant cluster of buildings, they should be treated as a cliff or quarry face – that is, as a whole rather than as an addition of pieces. Tall elements like spires and chimneys are valuable because they provide a vertical element to contrast with the majority, which is horizontal. If you are undecided where they should be placed, try one drawing with the pile right in the middle of your composition (Fig 66). No distant view will be truly symmetrical, so although the high point is centrally placed, there will be subtle variations in the landscape on each side. There are many other placings which can be tried as your experience in organising compositions develops.

The direction of light will provide a regular and logical sequence of dark and light, and the way that this is drawn will do much to describe the shapes (Fig 67). All those planes which are away from the sun will be dark, while those in full light will be light. You will find that light is a more valuable means of description than the actual colour and tone of a wall or roof. But once again there can be no firm rules: if the top of a tall chimney, which should be pale in the sunlight, has in fact become darker with soot deposits, then by all means make it so. If a lot of buildings have white walls or are very pale, in order to make this clear, areas round about, like roof and trees, might have to be made darker in order to bring out the paleness of the walls (Fig 68). You have to decide on the priorities and then endeavour to ensure that you get the point across.

In a drawing without colour, sky can be a problem: if the blue areas are shaded it is possible

55 *The areas in shadow create the effect of light on other walls*

that the sky will look very cloudy and grey, whereas if paler clouds exist then their contrast will suggest that the sky is probably clear and blue (Fig 69). In some conditions, however, if the shading is made too dark, the luminosity of the whole sky can be lost.

If the clouds and their shapes are an important part of your drawing, make certain that you allocate enough upwards space to do justice to the particular effect. Start drawing clouds as they approach your view. This will give you time to assess their particular shape and get some drawing down on paper as they arrive. It is very easy to get side-tracked, so that when you look up again you will find them rapidly disappearing out of your view. Because clouds are constantly chang-

ing, forming and evaporating, you will have to react speedily to sum up the salient shapes (Fig 70).

Shading takes time, so do not bother to extend and complete large areas of blue sky. You will know where they are in your drawing, and when the first rush is over it is perfectly possible to develop gently the right gradation of shading. When placing clouds, take care not to fit them conveniently around buildings, towers and hills. Since the clouds are likely to be far beyond the nearer landscape, some will pass behind tall elements. The care needed to make this happen sympathetically will do much to enhance the space of the sky (Fig 71).

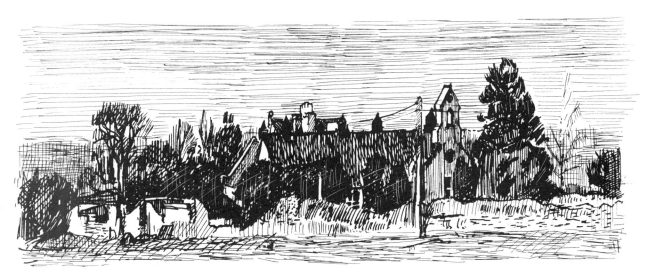

56 *A school in Wiltshire which nestles in its surroundings*

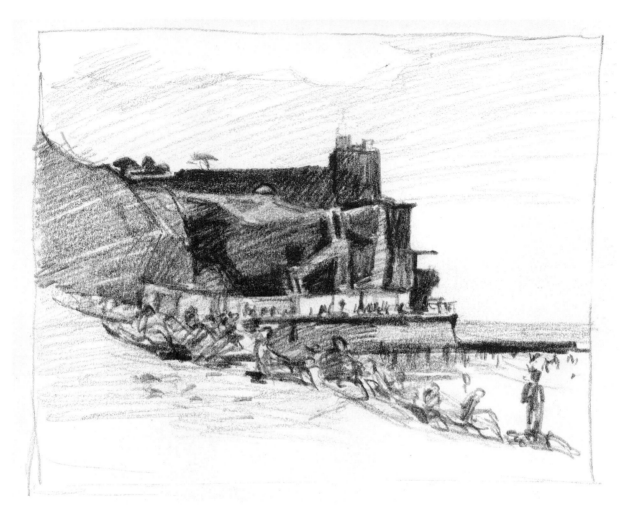

57 *Buildings and staircases constructed on and in the cliff at Sidmouth, Devon*

58 *A diagramatic view of a building seen below the observer's horizon*

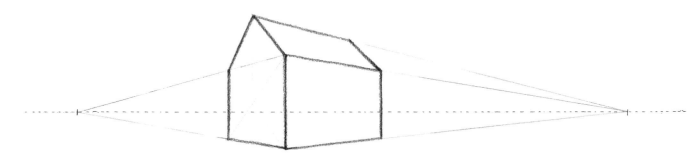

59 *This view of a building shows part below and part above the horizon*

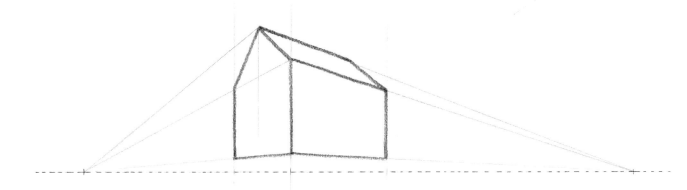

60 *All the elements of this building are above the horizon*

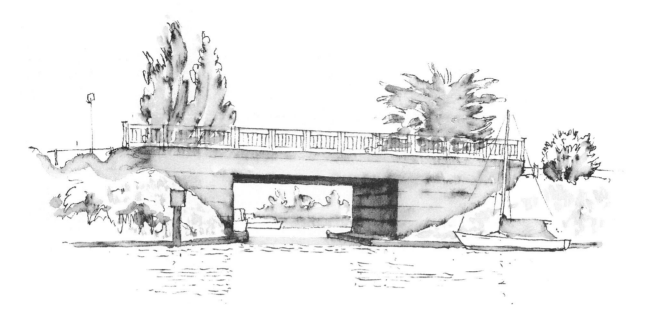

61 *The thickness of Ludham Bridge is crucial to its description*

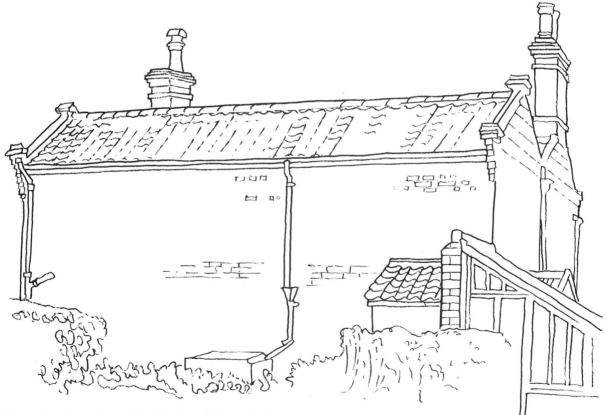

62 *A simple version of Fig 63, but without windows*

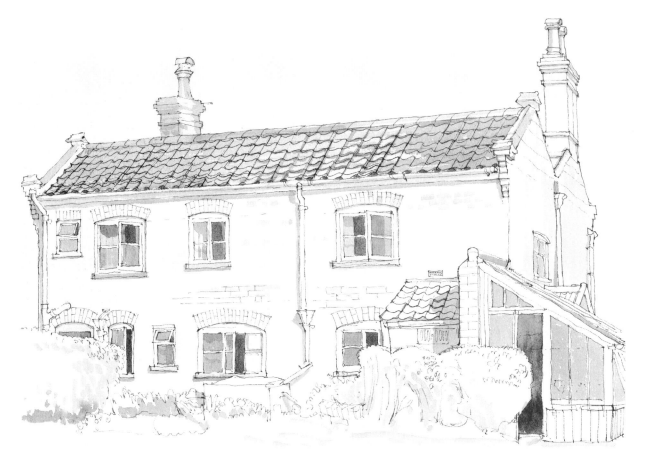

63 *Lynch Green House, Hethersett with its full complement of windows*

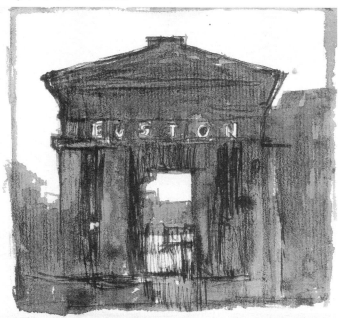

64 *The entrance to the old Euston Station, London, seen against the light (sadly this has now been demolished)*

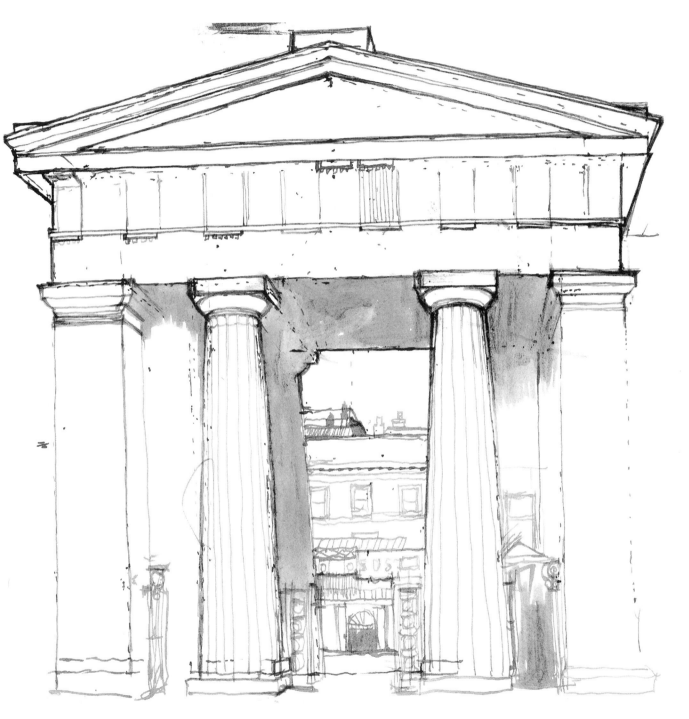

65 *A line version of the same subject as Fig 64*

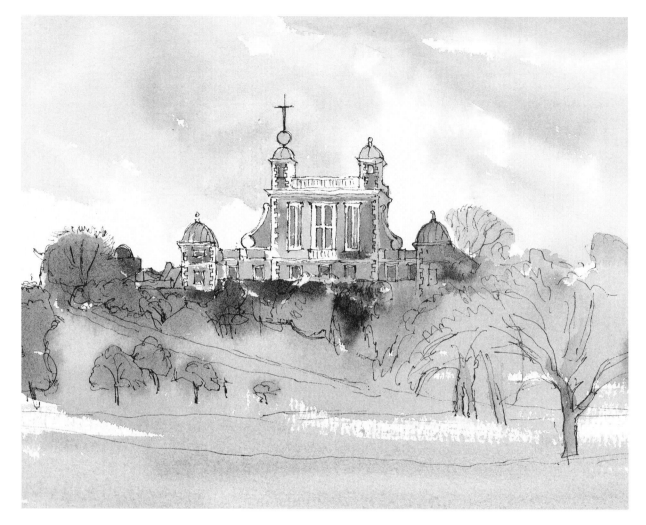

66 *Sir Christopher Wren's Greenwich Observatory placed in a central position*

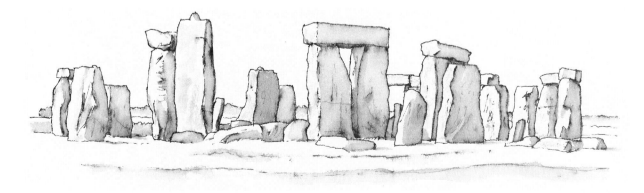

67 *Low light showing up the forms of Stonehenge, Wiltshire*

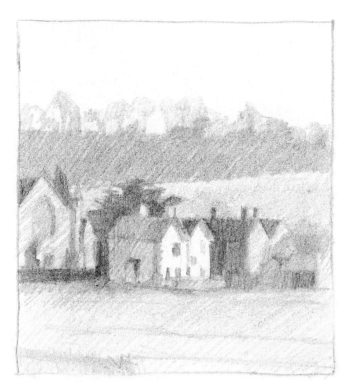

68 *Light areas can be brought out by making other areas darker*

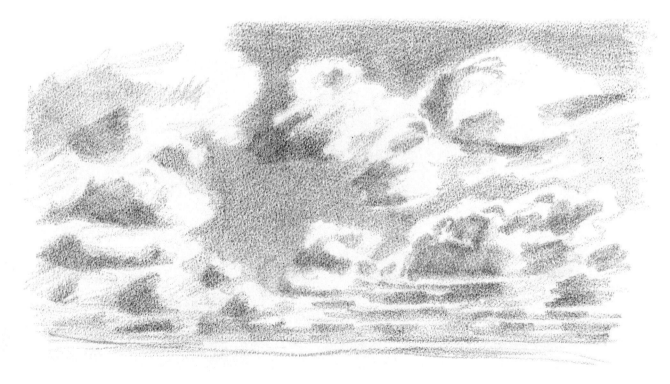

69 *Pale areas of cloud can create the contrast which makes a shaded sky be interpreted as blue*

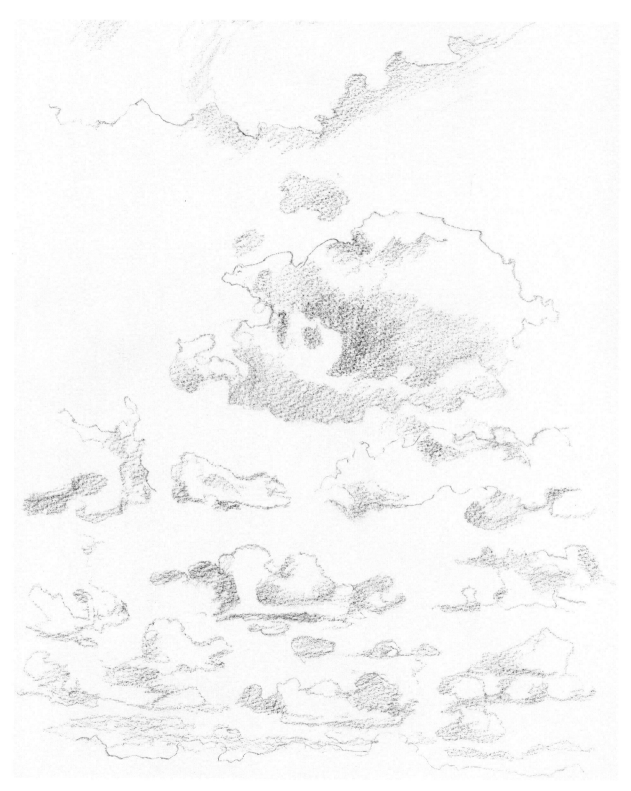

70 *Clouds have to be drawn quickly because of their ever-changing shapes and relationships*

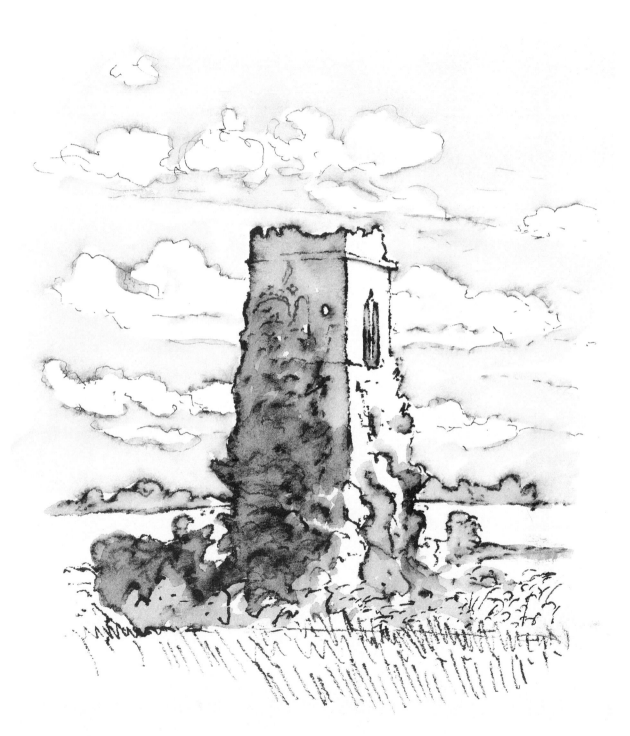

71 *Clouds pass behind tall objects – take care not to just fit them in on either side*

6

Landscape furniture

Nature and man constantly add to and take away parts of a landscape. I have seen the natural formation of an ox bow lake, beach levels rise and fall from one year to another, fields become houses, and trees become spaces (Fig 72). The artist unwittingly becomes a recorder. The landscape is full of individual items which might be described as additions to the greater overall scheme.

My home county of Norfolk is full of water – ditches and streams, rivers and broads, with the North Sea as a boundary. It is the sort of place which retains some timeless qualities and is full of shapes and textures which are very drawable. The strength and mighty force of moving water can be hard to describe, but if you watch the waves carefully, you will see how they repeat their action (Fig 73). Watch how their shapes move along a groyne or rock. By reflecting the colour and brightness of the sky, a puddle in a farm track can become a compositional element (Fig 74); not merely something to avoid stepping in, but something to describe with care.

Water presents itself in many ways. When absolutely still, usually in the very early morning or late evening, it will reflect the immediate land and the sky (Fig 75). It is quite easy to think of the object and add its reflection only as an afterthought. Try to draw both parts at the same time, for the structure of the reflection will appear as if the object were continuing downwards, upside down. Though in theory the size should diminish slightly as it is travelling away from the eye, the slightest surface movement of the water will enlarge the edge of the reflection, so that, if measured, it could well be found to be fractionally longer in its slight diffusion.

As soon as a breeze ruffles the surface, clear reflections vanish and the colour becomes a concoction of the reflections created by the angles of the wavelets. The basic law that the angle of incidence equals the angle of reflection applies, so while looking in one direction some parts of the water may reflect qualities of light from behind the observer (Fig 76).

Lights reflected in ruffled water may be seen many times. The moon, too, will have a reflection which repeats as each wave angle picks up the light. The brilliant sparkle in water or the light itself can be created in a drawing only by making everything else tonally darker (Fig 77).

Bridges are good things to draw – mysterious arches which frame views on the far side. The reflection of the arch will make it seem as if the bridge were constructed twice – once below the water surface – and all the directions will follow the basic rules of perspective. In addition, there will be a shadow of the structure, which will fall across the surface of the water (Fig 78).

Roads and paths give clear lines in the countryside, but a single line for their edge is hardly enough; edges of some thickness will need a second line, and where grass and deeper undergrowth start the light and shadow will produce a fat edge (Fig 79). When you see poles carrying telephone or electricity cables, notice how, as they recede, the intervals seem to get closer – as long as they are more or less evenly spaced when erected (Fig 80). This repetition of a regularly sized and spaced object is another way in which space can be described and the size of other elements of the landscape established. Fences and gates serve in a similar way, and their rôle can

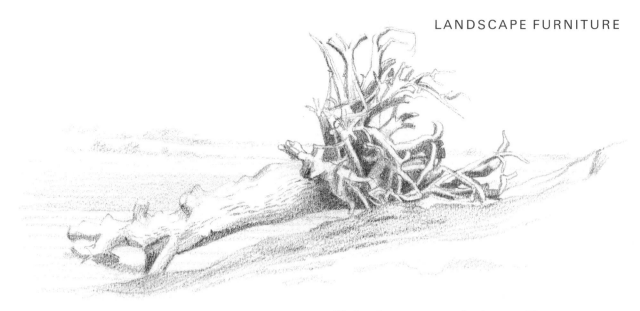

72 *Landscape constantly changes. The great storm of 1987 will have made the drawings of many artists an historic record*

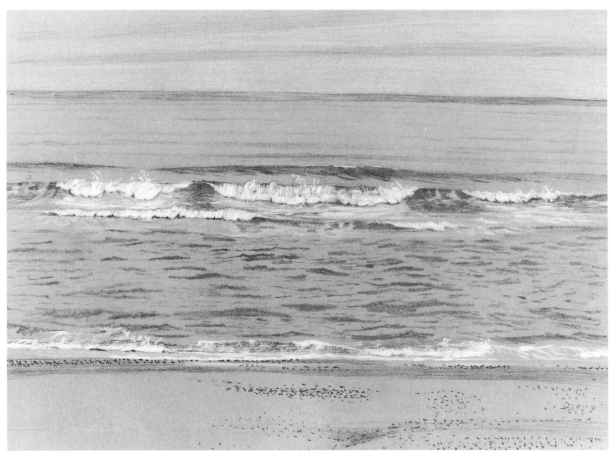

73 *Constantly breaking waves repeat their shapes*

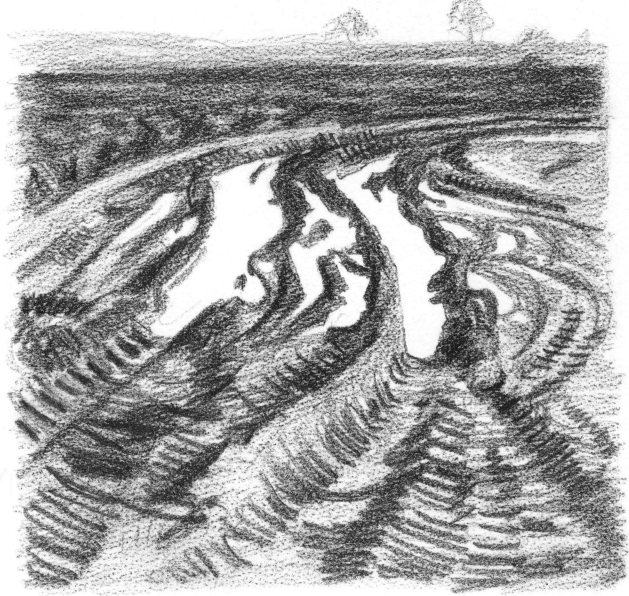

74 *Puddles in a farm track reflect the sky*

become quite evocative – the fence is a boundary and a demarkation, while the gate is the possible opening to a place beyond, and an open gate is an invitation to pass through (Fig 81). These elements can frame or give focus to distant views, but remember that fences and gates are made in precise ways for very good structural reasons, and when an open gate is drawn in relation to a fence, its vanishing point will be different from that of the fence. Notice, too, how its length is likely to be foreshortened.

In the nineteenth century artists loved the rustic scene – the wobbly fence, the open gate, the cart; a track in the undergrowth, a cottage and a distant view glimpsed beyond a gnarled tree. Though such a view can be found today, it is likely to be much crisper in every way. Woodland husbandry has improved, buildings generally seem better

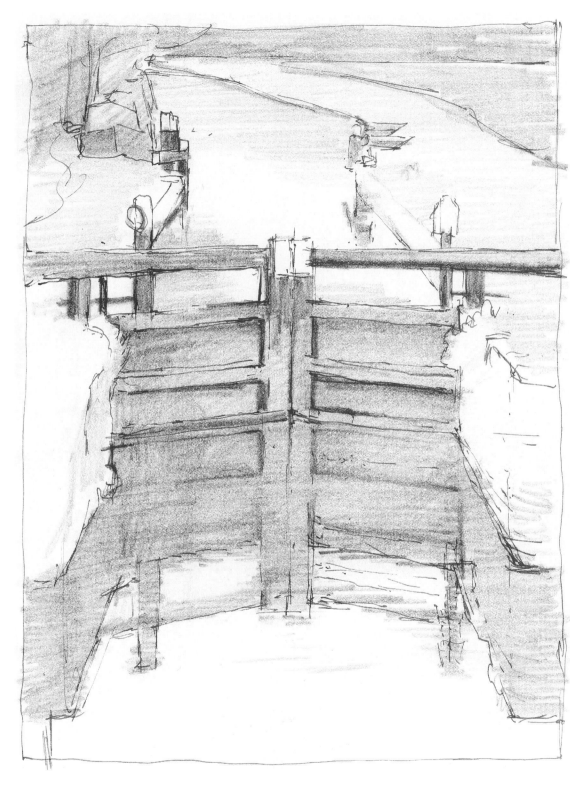

75 *A lock gate reflected in still water*

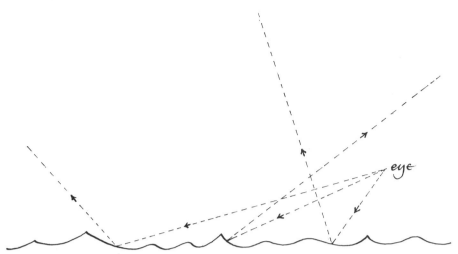

76 *Ripples on a watery surface may reflect many different parts of a landscape*

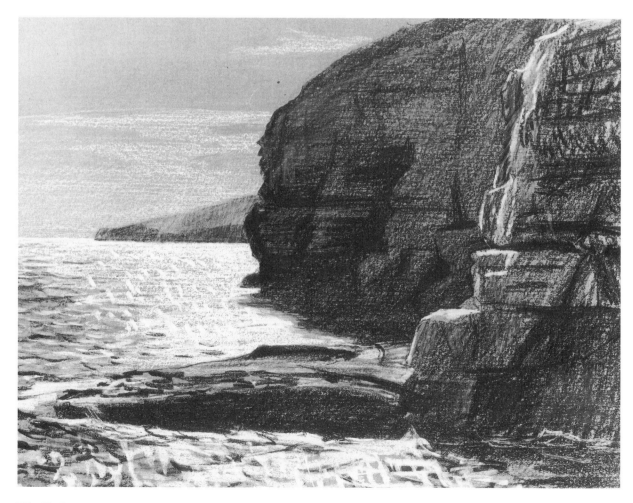

77 *Chalks used to describe the dancing light on the sea*

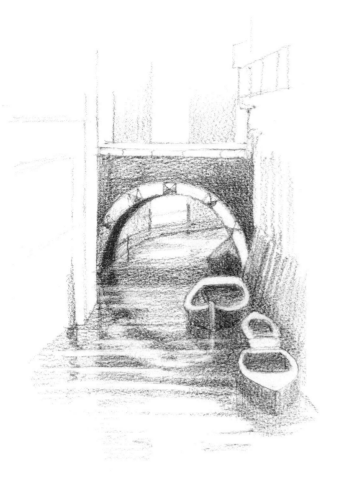

78 *A simple Venetian bridge with its reflection and shadow*

cared for, and stock is too valuable to permit inadequate fences. Yet although the tractor may have replaced the horse, the composition can be just as vital, and it will certainly be real and truthful. So do not be put off because of differences from a preconceived notion – even overstrong colours on houses will be mellowed in your drawing!

Animals add another texture to fields and need some careful observation (Fig 82). Try to sum up a particular pose – one where the animal will remain for just a little while at least. If there is a group, state the overall shape, but don't try for too much detail, as animals must appear as part of the field. They will have eyes and mouths, but from a distance I doubt if these need to be represented. To draw animals and birds requires practice. If they are to be a major part of your drawing, extra studies should be made. Visits to wildlife parks and zoos may provide views which permit longer periods of drawing (Fig 83).

If you are tempted to add some extra animal interest when developing a drawing, take care with scale. The human figure can provide one of the best sources of scale (Figs 84 and 85): there is an immediate understanding of how tall people are – $5\frac{1}{2}$ feet (1.7 m) is a rough average. When a person is standing by another object, its relative size can be assessed, and if one line from the head and another from the feet are taken to a vanishing point on the horizon, the height of any figure standing further away can be measured (Fig 86).

Other size relationships may seem obvious, but a mental check can help to keep them reasonably comfortable. For example, people must be able to get through doors, and grand doorways might be several times higher than usual (Fig 87).

If people are naturally involved with the scene you are drawing, there will be good reason for them being where they are, but think carefully before adding people merely for interest – they can often look artificial!

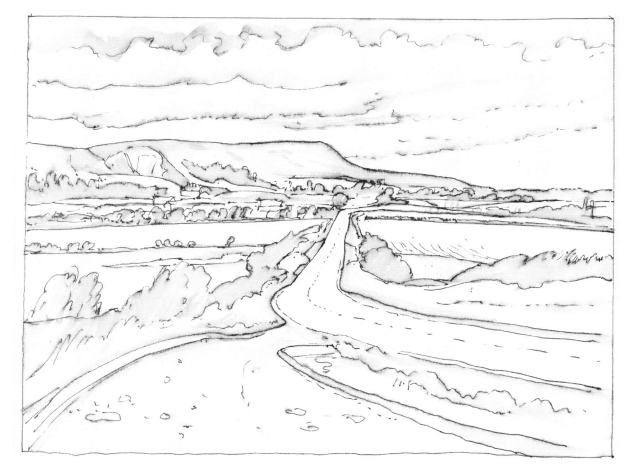

79 *Many boundaries need more than one line to describe the undergrowth and thickness of hedges*

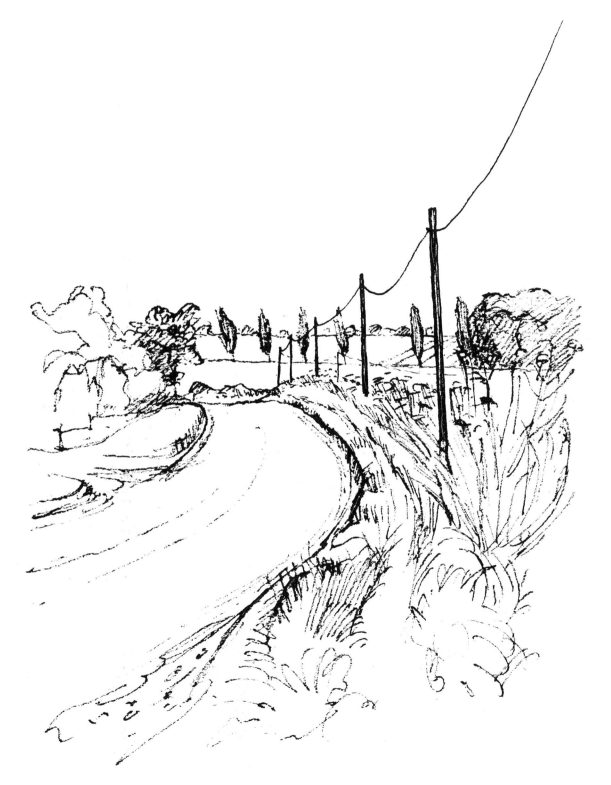

80 *Evenly-placed poles will appear to get closer together as they recede into space*

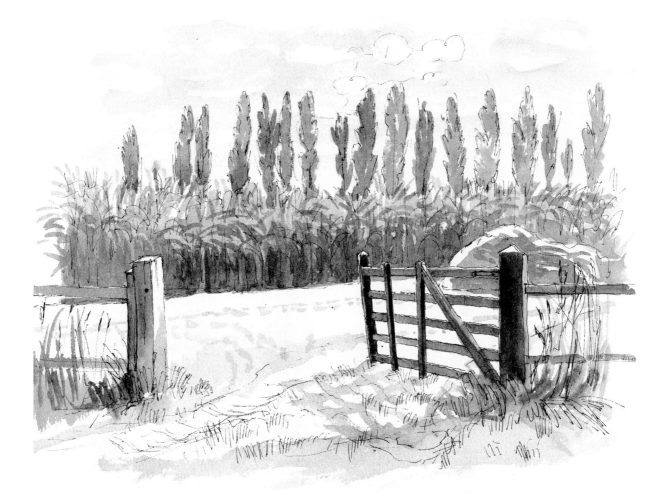

81 *An open farm gate at Watermill Farm, Blythburgh. Pen and wash*

82 *Animals create a particular texture in fields*

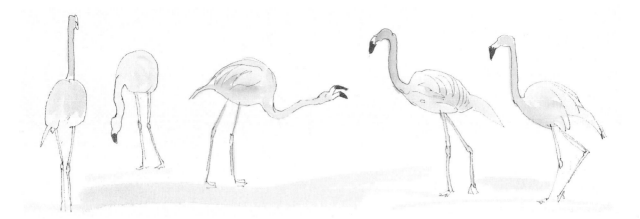

83 *Flamingoes drawn in a wildlife park*

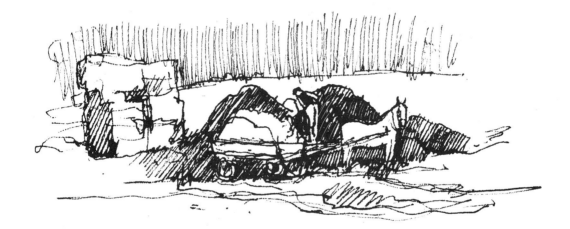

84 *A man working on a cart provides a valuable measure of scale*

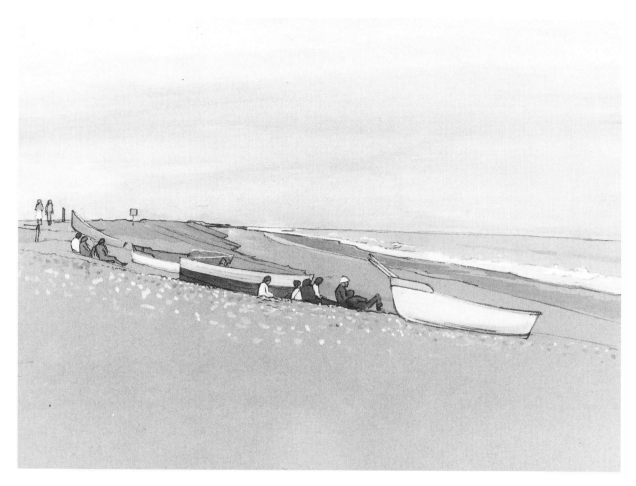

85 *People give scale to the boats and the size of the shingle bank at Cley, Norfolk*

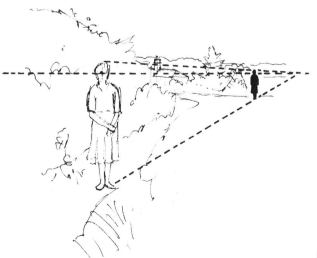

86 *One figure can give a guide to the size of any other figure in a drawing*

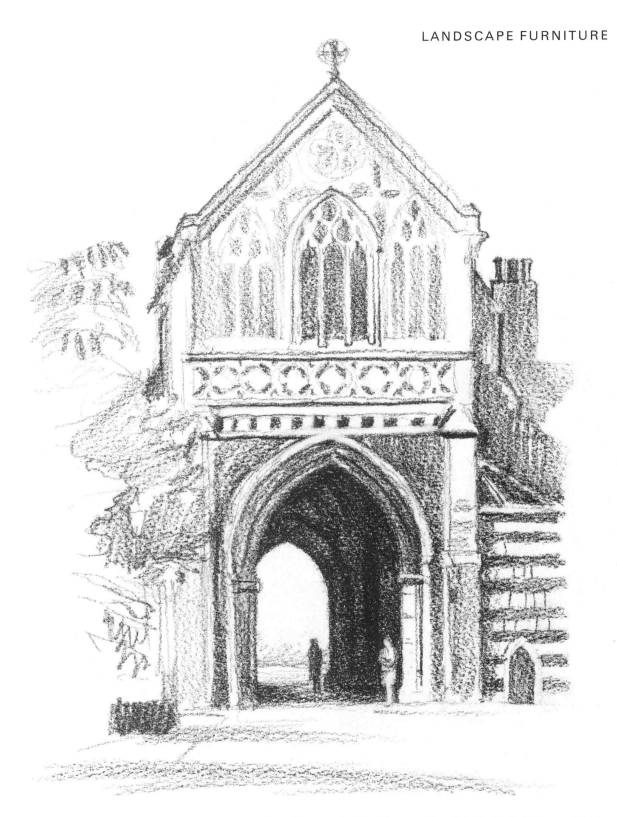

87 *Figures give a comparative size to the Ethelbert Gateway in The Close at Norwich Cathedral. Care might be needed to pass through the little door on the right!*

7

Dramatic variations

I well recall my first visit to Switzerland. I was not impressed on arrival because the area I was visiting was enveloped in mist. My first drawing was of the landscape across the valley to the point where it vanished into the cloud, and I guessed that the moutain was just above. As I drew, I sensed that the clouds were beginning to break. I tilted my head right back and saw a patch of blue as the clouds moved, and then, almost to my horror, rocks up in the sky. I had had no idea how close or huge that mountain was. Later, when the clouds had passed, I drew it again. I had to decide how much I could get in (Fig 88). The feeling I wanted to achieve was one of immense size, yet only by some comparison could I get that quality over. I could understand the distances by moving my head, but a drawing can really only take a monocular view. A large piece of paper on which to draw can help, and some measurable objects like buildings, trees or animals may assist in conveying the scale.

In contrast, any low-lying marshy area will produce strong horizontal elements. Most of the interest in the composition will be contained in a narrow strip running across the page (Fig 89). Above will be a vast sky, and, though some might call it bleak, personally I love that quality. Care has to be taken to give the lines of the fields, ditches and banks very true directions, however, for with so much happening in such a small space, one can quickly lose a whole field. Intervals are very important here, and there is also the problem of width – where do you stop in this wide panorama? This is most likely to be solved by finding a vertical element or clump of trees on which to end.

As you begin to appreciate how the feeling for a

view may not always provide the best subject for a drawing, so you may also become aware that objects which at first might seem commonplace can provide all the drama necessary for a drawn composition. Rocks and cliffs can have a powerful structure which is clear to draw, with crisp shadows and sharp facets (Fig 90), and, after winter flooding, grasses seen at close quarters can yield startling shapes (Fig 91).

The result depends on the priorities given by the artist. As much as anything it depends on a way of thinking. Rain can be a misty texture, not just something to make you wet. Fading light and the last of the sun can mean rich shadows and an air of mystery. Vehicle tracks across a field might mean spoilt crops for the farmer, but can be lines and shapes to the person drawing. All landscape contains some sort of drama, but it may have to be sought out.

Most of us enjoy climbing up and looking down! This might mean surveying the view from the top of a castle keep or merely leaning out of an upper window and looking down on a garden below. Patterns and shapes become immediately more recognisable. Views of excavations and quarries (Fig 92) or from cliff tops (Fig 93) all provide this view where space is given a boost. Yet in a drawing there may be little chance to convey this effect unless there are some absolutes against which the other parts can be judged.

A far horizon, or the horizon of the sea, can provide this admirably, giving a horizontal to which angled lines of hills can be contrasted. In other cases, the recession of similar objects, fence posts or even wild flowers, may be the only elements by which a dramatic view may be made

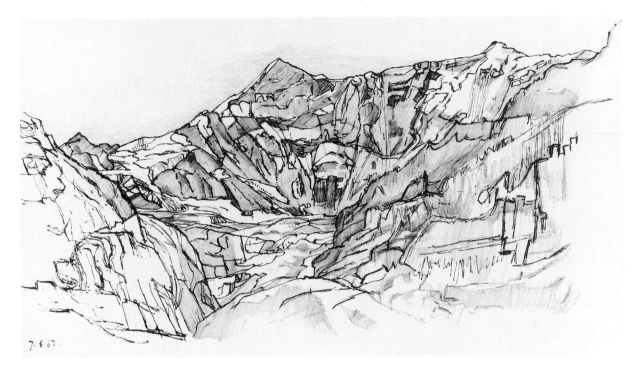

88 *The huge scale of mountains is not easy to convey in drawings*

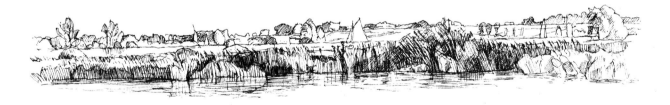

89 *A Norfolk landscape can exist in a narrow strip across the page*

to tell its full story (Fig 94). In the absence of atmospheric changes in colour, a bluer distance for instance, a monochromatic drawing must use ingenuity and be selective. Again, it might be that what is not put down on the page – a field left as raw paper for instance, without any texture or tone at all – could well be vital to the final success of the picture.

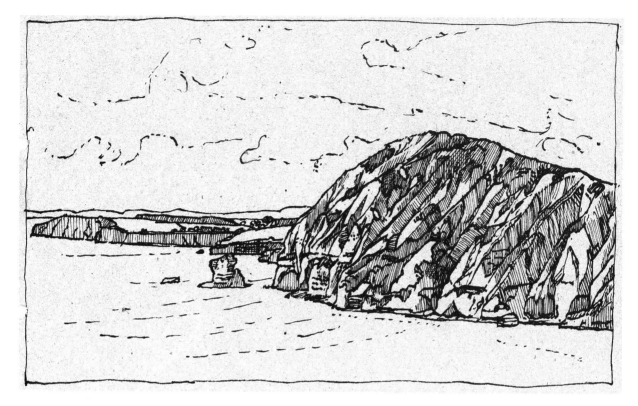

90 *Cliffs at Sidmouth, Devon*

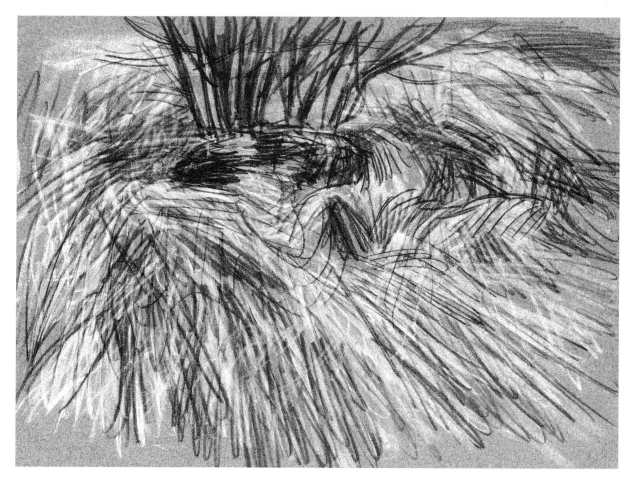

91 *Swirling shapes of grasses after winter flooding*

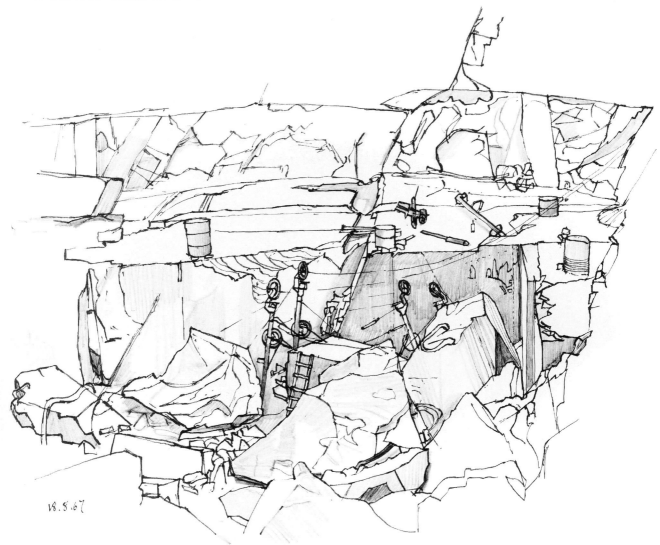

18.5.67

92 *Looking down into one of the quarries at Carrara, Italy*

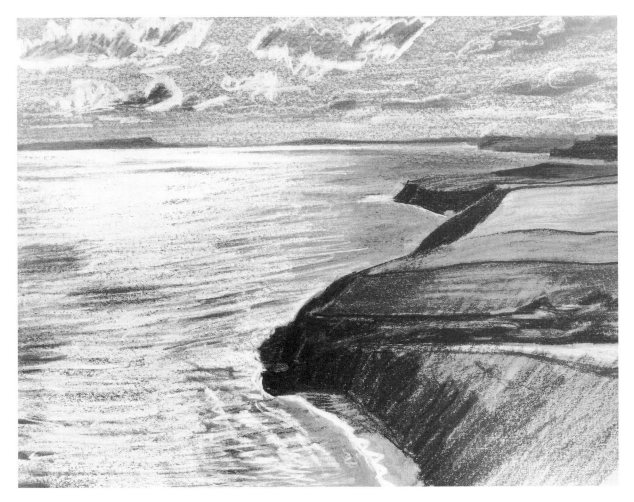

93 *A steep climb was rewarded by this view towards Portland Bill*

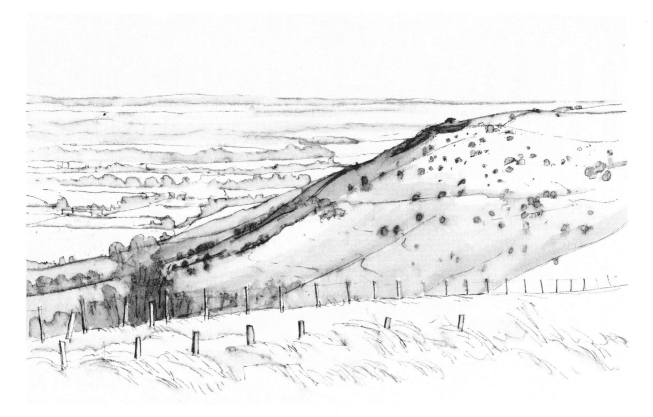

94 *The slope of the Downs contrasts with the horizontals of the fields below*

The refinements of composition

There is a magnetic relationship between the parts of a good composition. A picture is a strange thing – an arrangement of shapes in a rectangle which represents things we have seen (Fig 95). The paper starts out as clean and clear, then marks and blobs are added until an observer exclaims at the recognition of a familiar place. Yet the familiar place has become graphite or ink, chalk or charcoal. The marks are symbols: just as on this page the letters of the word 'tree' summon up an image, so too the marks you make produce a visual image.

There can be many suggestions of ways to begin drawing, but to describe the qualities by which excellence may be obtained is at best likely to be very fragile. The most hesitant beginner and an internationally recognised artist will, when looking at a landscape, have almost everything in common, yet in the hands of, say, Constable or Turner there will be some elements or qualities extracted from it which will turn the common-place into a memorable drawing.

Much can be learnt from looking at drawings by major artists. Exhibitions and museum collections provide many opportunities for looking at actual works. This is preferable to looking at reproductions, as the way the marks were made will be much clearer and so will be more helpful in assessing your own work. The actual size will also be appreciated, for a great number of reproductions do not show the works at their correct size – indeed, some only show part of the original. This close study of how the drawings were made and how they were composed will also enable a personal choice to be made, for of course we do not all admire equally every period and style.

As your drawings progress, further thought can be given to composition. To help this, use two L-shaped pieces of card to form the edge of a rectangle (Fig 96). If you hold these up in front of your eyes, the contents within the view will be clearly selected. The proportions can be varied – the possibilities of a broad thin shape, a tall thin shape or a square can all be tried – as can the overall size, by moving the pieces apart or holding them closer. Within this rectangle, all the potential parts of the drawing can be considered. A more readily available version of this procedure is to use your fingers to construct a rough rectangle, but this limits extreme variation of proportions (Figs 97 and 98).

The sketchbook or sheet of paper is of course of an arbitrary shape. It should be of a size suitable for holding or pinning to a drawing board, and of a proportion which allows choice and variation on the part of the user. But neither size or proportion should dictate to the artist what the shape of the drawing will be. I do feel that if a drawn boundary is made within the edge of the paper, the picture edge will become much more vital and the decisions about composition far simpler to make. These decisions will not always be right, but without this limiting edge landscape can have a way of simply going on and on until the edge of the paper is reached, whether or not that is the best place to stop the drawing.

Again, there are questions which you can ask. Is everything vital? If there are parts you dislike, then reduce the area selected. What it the lightest tone in the view? What is the darkest? Which drawing materials would be best to use? Would a line drawing describe what you see? How would the

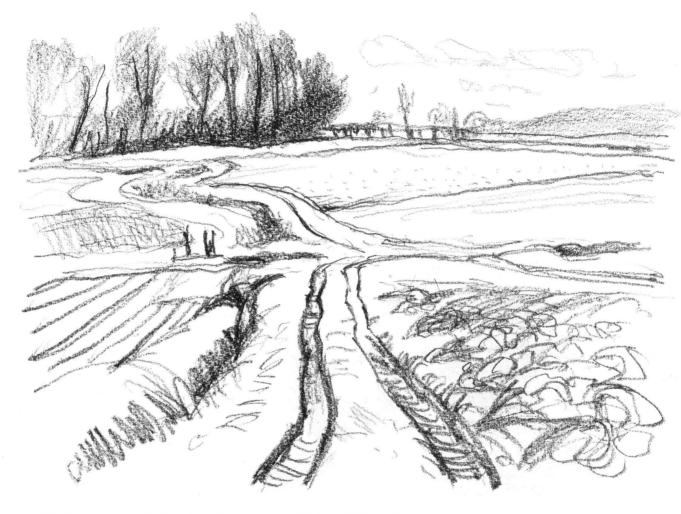

95 *An arrangement of marks which represent ditches, fields and trees*

composition appear if there were only lines? Would the dark areas have the same importance if they were simply described by a few lines? Would the lightest areas appear different from any others if they were simply outlined? If not, could selective textures be introduced to define a variety of areas? Of course, these are not the only questions which could be considered, but what is important is that thought is given.

The golden section was once thought to create a division of a rectangle which had a special quality. In technical terms it is described as a line which is divided in such a way that the smaller portion is to the larger as the larger is to the whole, i.e. the area AB is cut at C so that CB:AC = AC:AB. A near accurate proportion is 5:8 (Fig 99).

Since most objects are not a single dot but cover an irregular area, its application in practice is quite usefully vague. Consider the ratio based on the sample in Fig 99 and try placing your most important object, or the point of focus, at the golden section (or mean, as it is also known). I do not feel that a mathematical calculation is necessary, but simply a sympathetic placing in the spirit of that proportion. However, since compositions create atmosphere and a feeling of movement and change, other placings may produce the quality desired.

Of course, in a landscape, the focus of a composition may not be a solid object in the normal sense. For instance every now and then a particular cloud formation can be spectacular (Fig

100). The shapes will arrive from one side and travel away at the other. Shapes which are cut off by the picture's edge can be very important. They not only create a feeling of movement or change, like people passing by outside a window, but they lock the composition on to the edge of the rectangle (Fig 101). If all the objects in a landscape were seen totally within the area described by the edge, they might look rather like scattered potatoes on a plate. The shapes at the edges will make a border and, by so doing, allow the eye to move into the picture's space.

If a tree is at one edge, too little of it might look very strange – just some leaves popping in at the side as if from nowhere (Fig 102). Half the tree could appear equally odd, possibly looking as if the trunk were growing up the side of the picture (Fig 103). Getting the trunk on, but not the whole

tree, might be the best of the options (Fig 104). If the whole tree is on but just touching the edge of the composition (Fig 105), this could have a similar feeling to the half trunk, so if the whole tree is on and a space left, perhaps the whole question starts all over again when the next tree is reached!

Of course it is a matter of choice, and trial and error, but the composition which is drawn within a boundary line will be easier to consider. A faint pencil line, or dots made with a pen, can be modified as you make compositional decisions and then confirmed as the drawing progresses. But the drawn edge will help because it will enable you to draw from the edge into the centre of the picture. Otherwise there will be a tendency to draw from the middle, and only stop when the paper runs out.

96 *Two L-shaped pieces of card can be held and the proportions of the opening varied at will*

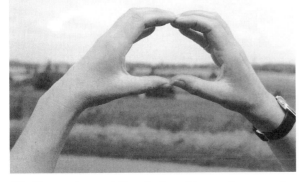

97 *Finger tips and thumbs touching make a rough boundary to help isolate possible subject matter*

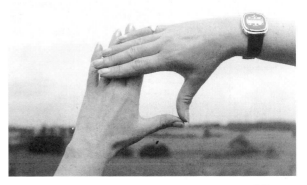

98 *A variation of Fig 97. This arrangement of fingers and thumbs can create a rather more rectangular shape*

A 8 C 5 B

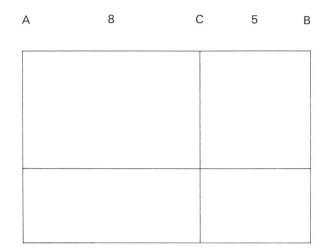

99 In a landscape with a proportion of 3 wide to 2 high, the Golden Section would divide the rectangle as here, 8:5 (total of 13 parts). For example, if the width were 180 mm

$$\frac{180}{13} = 13.8 \times 8 = 110.4$$

Thus the divide would come at 110.4 mm from one end. If the height were 120 mm

$$\frac{120}{13} = 9.2 \times 8 = 73.6 \text{ from top or bottom}$$

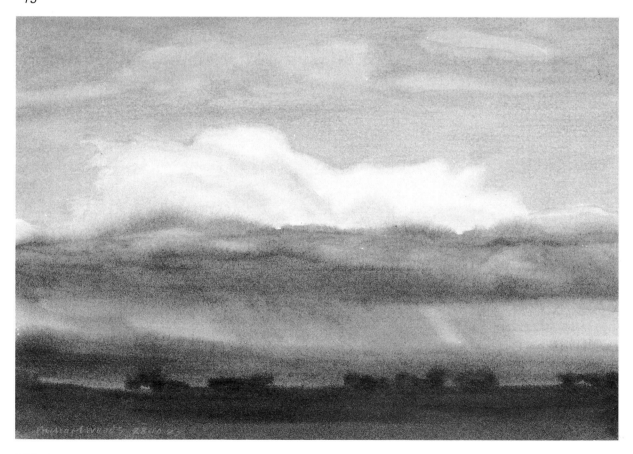

100 A watercolour study of a striking cloud formation over Norfolk

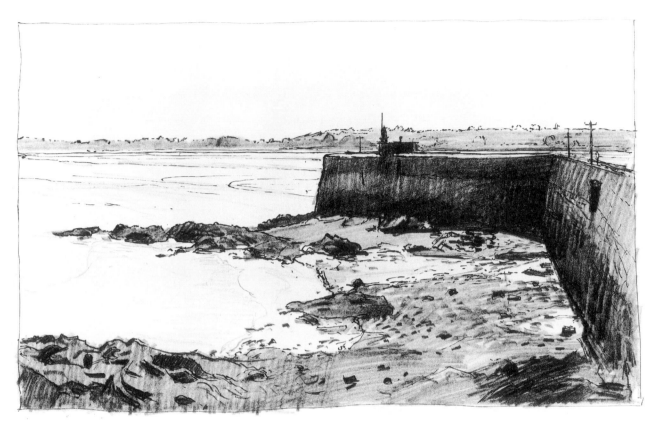

101 *The shape of this harbour wall at Gorey in Jersey locks the composition on to the right hand side of the rectangle*

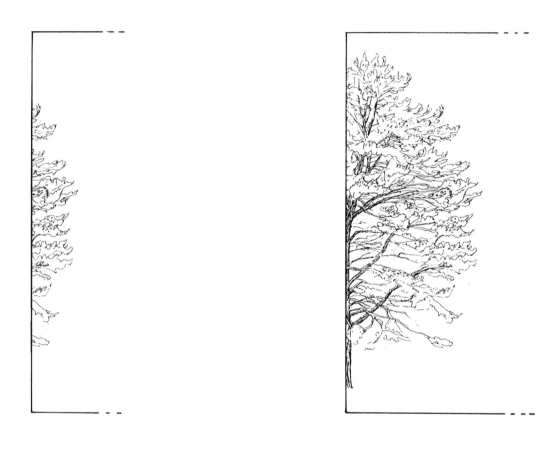

102 *A tree indicated by leaves just showing in the composition*

103 *Half a tree can look odd*

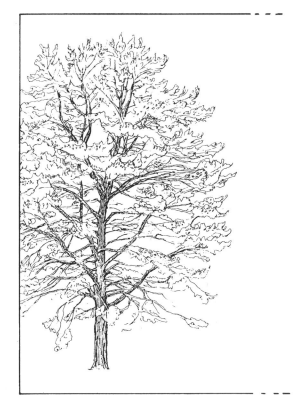

104 *Possibly the most comfortable amount of a tree seen at the edge of a composition*

105 *Almost a whole tree, but just touching the side of the picture, can be an uncomfortable version, being neither really cut off or totally on*

83

9

Materials, methods and presentation

I feel quite strongly that drawing landscape means working outside, on the spot (Fig 106). If the climate is good, then working will be quite straightforward, but if, as I frequently find, you are trying to draw with a brisk wind catching the edge of the paper and doing its best to lift off your hat, then you will be glad that the chosen materials are as simple as possible. A 2B or 3B pencil will produce both delicate soft lines and rich solid shading, yet will not blunt too quickly. Use a knife blade to sharpen it to a long flat point (Fig 107) (pencil sharpeners produce a short point which quickly turns to a blob). The knife should be keenly sharp or one with replaceable blades, as it is impossible to sharpen a pencil properly with a blunt knife.

It is possible to use coloured pencils, although I have never found the quality of the colour they produce to be really rich enough to describe those found in most landscapes. There is a tendency to use just 'the green one' for trees and 'the brown one' for earth – and the colours are not sufficiently precise. When mixed by working one over another, the colours tend not to integrate. Coloured chalks do produce greater richness, but are best used when working on a large scale – and that, at an introductory stage, can itself be a problem, for the larger the drawing, the longer it can take. Black chalk on its own can be very effective and is much more appropriate for the size and timespan.

The pen is one of my favourite drawing instruments (Fig 108). The eraser is abolished, for there is only one chance for every mark. This makes you think first – excellent practice for all of us! As a student I ruined many a jacket carrying round a metal-nibbed dip pen and leaky bottles of Indian ink – excellent for drawing, but creators of incredible mess. Happily, some manufacturers have developed really excellent drawing pens using fine Indian ink which will be waterproof when dry – or non-waterproof, very black ink. The latter, in cartridges, is particularly clean to use. The waterproof ink enables a wash of watercolour to be laid over the top, while the non-waterproof variety can be over-painted with water so that it produces its own tonal wash (Fig 109). This is especially good when travelling, as it means that all you require is a small plastic bottle of water – or a good deal of lick!

The choice of paper on which these pens and pencils may be used is very wide indeed. There is no difference in the term sketchbook or drawing book. 'Sketching' sounds more casual, while 'drawing' seems a bit more intense, but what is important is the quality of the paper.

A small pocket book of 4 in × 6 in (10 cm × 15 cm) containing about fifty pages of smooth thin paper can be ideal. The definition of paper thickness is described in gsm: for example, 50 gsm. A thicker, better quality paper might be about 90 gsm, while paper thick enough to not wrinkle too much when given a water wash might have to be 200 or 300 gsm. It is worthwhile having a variety of books and a variety of sizes as well. Bound books are most durable for the pocket, or where they are vulnerable to handling, but when a size of about 10 in × 14 in (25 cm × 35 cm) is reached, I prefer spiral-bound books. The pages of these have the advantage of being able to be folded right back so that the working size remains the same. The spiral holds one end while small clips can hold the two remaining corners. This system is

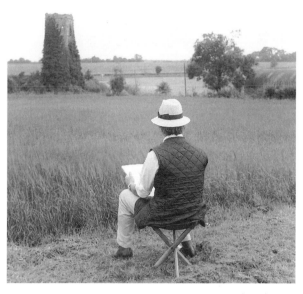

106 *Drawing landscape invariably means drawing outside from the actual subject*

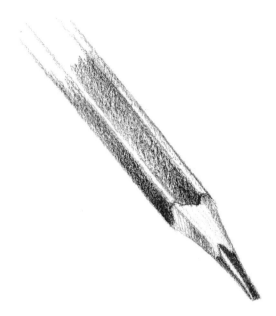

107 *A long flat point probably provides the most versatile working end of a pencil*

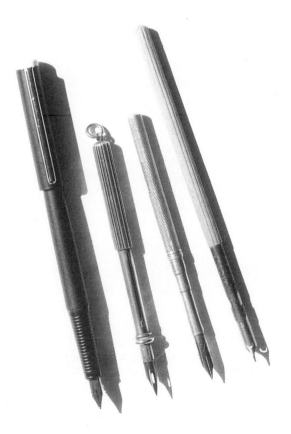

108 *Four pens used for drawing. Left to right: A proprietory brand of pen using a cartridge, with the option of a refillable container enabling Indian ink to be used: wash out frequently to preserve smooth ink flow. An old silver rectractable pen and pencil; the pen suitable for dipping only. A silver pen with the handle giving protection when the nib holder is reversed. It has a gold nib which is very pliable and pleasant to use. A wooden handled dip pen with a steel nib. Many styles of nib are available*

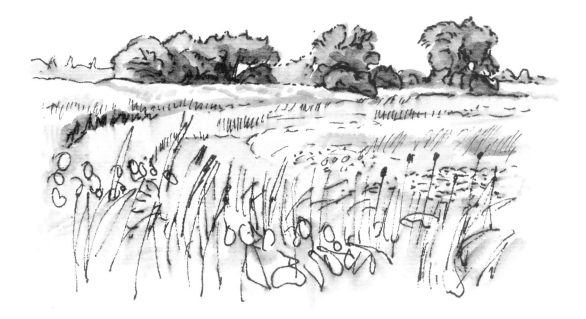

109 *A non-waterproof ink wetted with a licked brush to develop tones – practical, if unhygienic!*

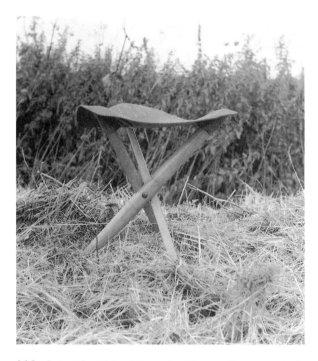

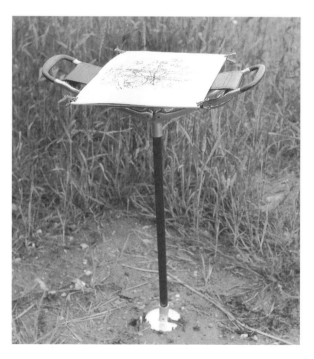

110 *A comfortable old stool with a leather seat, but because it is low some views can be hidden*

111 *A shooting stick can be used either as a seat or as a mini-table*

fine up to about 16 in × 20 in (40 cm × 50 cm) but beyond that a drawing board and separate sheets of paper are preferable, as big drawing books can become quite heavy to hold. However, if working conditions are at all windy, changing sheets of paper on a board is anything but easy! The board itself might be lighter if made from cardboard or some sort of insulation board, but you will need to use clips, as pins will not hold.

When drawing outside I hardly ever use an easel – although very light, portable ones can be very good – but I do find a seat of some sort is useful. I use a very comfortable old tri-point stool with a leather seat (Fig 110), but it is low and in high undergrowth this can be a disadvantage. A shooting stick with a large seat is my other support, but if the ground is sloping downwards – and it often can be when looking at 'views' – its height can be a problem. However, with the point firmly pushed into the ground, it can serve in another way, as a mini-table, and this can be particularly useful for putting in washes, when the drawing needs to be flat (Fig 111).

A pencil in a pocket can suffice, but a drawing bag in which a collection of items can be carried is invaluable. It is not likely that it will be large enough for your biggest book or board, but one 10 × 14 in/25 × 35 cm can generally be accommodated, plus pencils, pens, water bottles, fixative, and anything else necessary for your wellbeing in order to keep you drawing!

Back home, you might be tempted to finish a drawing. Don't. Rather, try making a completely fresh drawing using your first as a source of information, and then developing the new one to a stage further than that made on site. The original drawing will have natural, if chance, qualities which will be lost if fiddled with. I use my drawings as a supply of information for paintings – but I would never add indoors a wash to a drawing made outdoors. Making a totally new work will ensure a greater unity.

I am sometimes asked if I work from photographs: I do not. I cannot believe that anyone who likes drawing and wants to record reactions to a particular environment will get much satisfaction from referring to photographs. The strange thing is that the human eye, in league with the brain, selects in a way quite different from the camera. In many cases the photograph can provide far too much information, and a drawn copy will invariably look mechanically artificial. What the camera can do, I must agree, is to help in checking certain facts. For example, how many panes of glass were there in a window; how many bars on a gate? By all means take photographs, and certainly make drawings, but do not intermix them – each will have its own merits.

The appearance of drawings can be greatly improved if they are mounted and framed. The question of composition can then be reconsidered. If the edge of a drawing – whether a rectangle or a vignette (that is, a loose shape of the drawn objects alone) is shown, then it will tend to look free and the appearance of the drawing is likely to be given its fullest qualities (Fig 112). If the edge is covered, indeed if only part is selected for view, then the appearance will tend to look tighter and possibly more realistic, but will lose something of its free drawn quality (Fig 113). It is a matter of choice, and one made easier by using large L-shaped card pieces laid over the drawing, when the opening size can be adjusted. An old card mount cut at diagonally opposite corners is ideal for this. A simple paper mount can be cut and if a pencil line is drawn say $\frac{1}{2}$ in (15 mm) around the opening, it will do much to improve the appearance within the chosen frame. A card mount is not difficult to cut, and this aspect of the presentation might be extended as experience grows. Of course, when a drawing is hung on a wall it becomes part of the room, and so the colours used in the mount and frame should be considered in relationship to their surroundings.

But, for the artist, the greatest pleasure will come from being in the countryside, feeling the sun, and drawing. No artist could ever have a bigger studio.

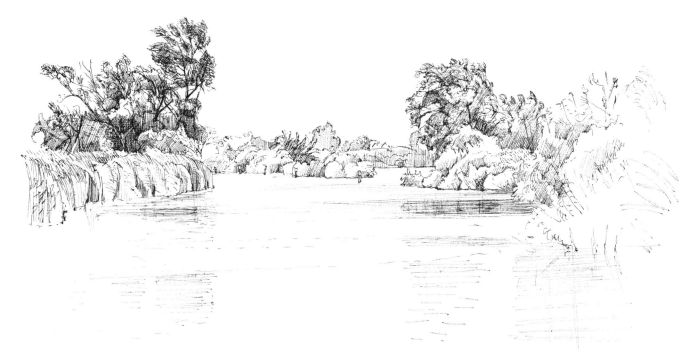

112 *A mounted whole drawing can show the free drawing qualities*

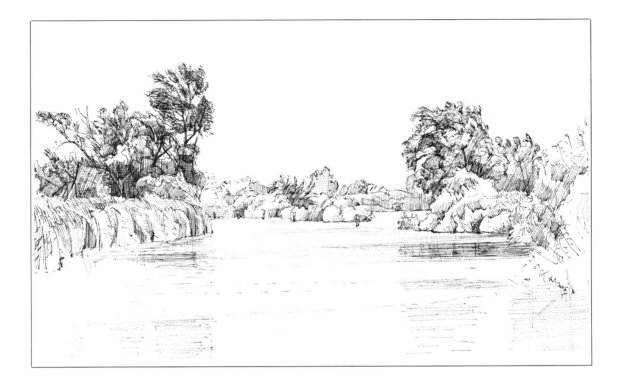

113 *The same drawing as in Fig 112 but with the loose edge covered. This probably looks more realistic, but possibly loses something of the drawing quality*

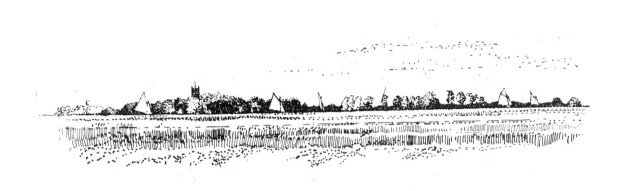

Glossary

Atmosphere A condition in which distant objects appear less sharp or have a softer tone because the air through which they are seen is not totally transparent

Boundary line A line describing forms where they turn out of sight

Chalk Dry sticks of pigment for drawing. The degree of hardness can vary considerably to a point where, when extremely soft, they might be called pastels. Some types have a wax or oil base which makes them more creamy in use

Composition An arrangement of a set of shapes and/or tones within a border

Constable, John (1776–1837) English landscape painter of meadows under breezy skies

Cross-hatching The technique of obtaining an area of tone from lines drawn closely together and, by stages, lying at different angles from one another

Darks An area receiving or reflecting a small amount of light. Described as a dark or low tone

Diluted ink wash A tonal area created by adding water to a basic ink to make paler tones. Applied to a drawing with a brush. Chinese stick ink can be ground to create beautiful greys

Fixative A proprietary preparation which can be sprayed on to a drawing to prevent smudging

Foreground That part of a view or composition which lies closest to the observer

Foreshortened A loose term describing the apparent shortening of a dimension due to visual perspective. Since all three-dimensional objects are likely to show some aspect of perspective, the term tends to be used when extreme shortening takes place

Golden section An irrational proportion which was thought to hold a special harmonic relationship, defined as a line which is divided in such a way that the smaller part is to the larger as the larger is to the whole. It is roughly a ratio of 5:8 (and is also roughly a ratio of 8:13)

Graphite The traditional pencil has a 'lead' which is in fact a fired mixture of graphite and clay

gsm Grams per square metre. 100 gsm is an average thickness paper for sketching; thicker paper suitable for wetting without undue distortion might be 300 gsm. An older measure was given as pounds per ream of a specified size, e.g. 290 gsm or 140 lb

Horizon A line directly ahead at the observer's eye level, at which a flat landscape or sea appears to meet the sky. This should not be confused with the skyline

Horizontal A straight, level line running to left and right. It lies at 90° to vertical

Indian ink A dense ink which is waterproof when dry

Landscape A broad term describing a geographical environment

Lights Areas receiving or reflecting a large amount of light. Described as a light or high tone

Line drawing A drawing made from observing both outside forms and inside structure, but without the development of solid tones

Monocular Drawing can only represent a view taken from one point or one eye

Mounting card Card with a fine cake-like texture which is firm, but easily cut

Parallel lines Continuously equi-distant lines. For the artist this is a known condition, but rarely seen

Pencil grades 2H is harder than H; HB stands for Hard Black; 4B is softer than 2B. When possible, use one make of pencil, which will provide consistent grade relationships

Perspective The art of delineating objects in a picture in order to give the same impression of relative positions and magnitudes as the actual objects do when viewed from a particular point

Plane A flat surface of infinite size

Reflection An image of an object seen in a reflective surface like water or glass. The shapes seen will be related to the angles of the eye to reflective surface and surface to object

Scale A judgement of relativity, important to any artist. Whilst it is possible to draw individual objects with care, the way they relate to one another is crucial for correct scale

Shading A process applied to pencils or chalks by which the descriptive variations of tone are built up by successive application of marks

Shadow An area which, by the intervention of an object between it and a source of light, receives less light in a shape related to the object. The term can also be applied to that part of an object which receives less light

Skyline A general term for the line where sky and earth appear to meet. According to the terrain the line may follow hills and valleys. This should not be confused with the horizon

Space Thought of as 'nothing', its presence round or between objects can be vital in the making of a successful drawing

Still life A group of inanimate objects

Texture Complex structures or materials may create texture. Strong light may reveal it, while low light may subdue it to a plain dark tone

Tone The degree of lightness or darkness of any colour

Townscape A subdivision of the broad term 'landscape', where man's presence is more consciously seen in the form of buildings

Turner, J.M.W. (1775–1851) English landscape painter. Some of his slightest studies make profound statements

Vanishing point A point to which all lines which are made parallel appear to converge and meet. In most cases it will lie on the horizon. Exceptions would be rising planes, where it would lie above, or descending planes, where it would lie below, the basic horizon

Vertical Upright, perpendicular, at right angles to horizontal

Volume A consideration of the three-dimensional bulk or mass which the artist has to describe in two dimensions on a flat surface

Watercolour wash A tonal addition to a line drawing using a thinly diluted watercolour pigment

Water wash A tonal area created by laying clean water over a soluble ink line. Some of the ink floods into the wetted area

Index